ICONS

T0204456

Devils

Gilles Néret

TASCHEN

KÖLN LONDON LOS ANGELES MADRID PARIS TOKYO

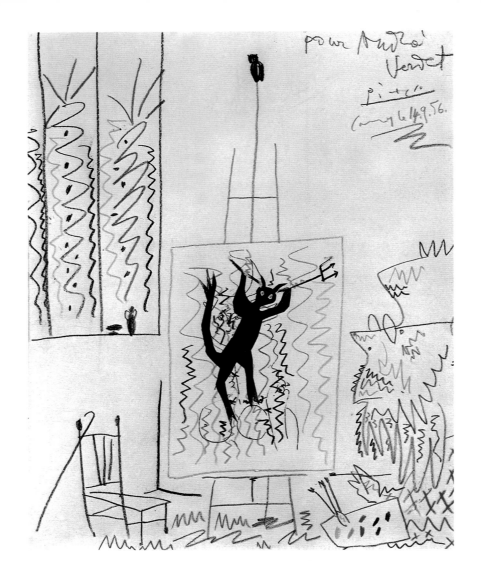

Pablo Picasso *The Devil in the Workshop*, 1956. Private collection

Contents | Inhalt | Sommaire

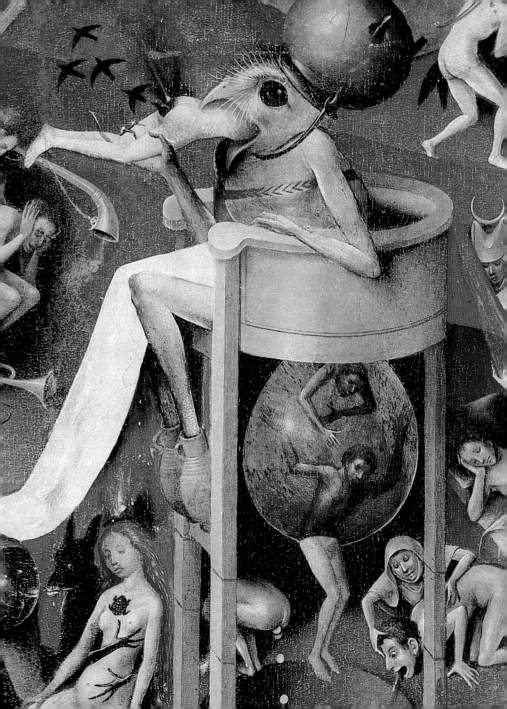

Lucifer and Company

The Romans called him *Diabolus*, and the Greeks before them *Diabolos*, the ›Slanderer‹. In classical mythology, the spirit of evil was called *Demon*, from the Greek word *Daimon*. Hell had long existed, in Egypt, Assyria, Israel, Etruria and the Far East, wherever the admittedly rather vague principle of the punishment of the wrongdoer existed. Faith teaches us that God created the angels pure and good, but subjected them to a test. Some passed the examination triumphantly, while others rebelled and were eternally tortured in Hell. These are the fallen angels: devils and demons. They owe fealty to the *Devil*, who is often referred to by the names of *Satan* (enemy or evil one), *Lucifer* (the brilliant), *Beelzebub* and *Old Nick*. These angels, when they fell from grace, contrived nevertheless to retain some of the gifts that made them superior to humans. Thus they are still capable of exercising their malefic power in the world. They tempt humans, luring them toward evil. Implanting passion and obsession, they can utterly derange human faculties. Their power over the physical world lets them perform uncanny feats. So it is no surprise to find that no one – with the exception of woman – has so inspired the artistic imagination. The incarnation of evil appears in the most various forms: serpent, toad, ancient gods and goddesses, monsters and fabulous beasts. The most widespread representation took shape in the 12th century; he has human shape, a hairy body, pointy ears and cloven hooves. These are combined with horns and a long tail. The bat-like wings with which Giotto, Bosch and Botticelli equipped their demons derive from Chinese paintings in the style of the Li Long Mien scrolls. The horns and cloven feet of Satan betray a Mediterranean source: *Pan, Dionysos* and *Satyrs* share these attributes, which were themselves borrowed from certain Palaeolithic sacred figures. Thus tradition ensures the demonic kinship of Assyrio-Babylonian genii with the gargoyles of our cathedrals, and the Khmer masks with the grotesques of Grünewald and Callot. (In the same way, the dislocation of bodies dear to Goya and Picasso had already appeared in the sculpture of ancient Mexico.) Jean Wier, a 16th century demonologist, counted 7 405 926 demons, all of them »filthy and foul«. The favourite role of the devil, gleefully rehearsed by the artists, was as supporting actor in depictions of the Last Judgement: souls are weighed and seized, and the damned harrowed in many excellent and innovative fashions. In the 16th century an admirable concern for methodology and order led Bishop Pierre Binsfeld to hand responsibility for each mortal sin to a particular devil. So *Lucifer* presided over pride, *Mammon* over avarice, and *Asmodeus* over lechery. *Satan*

commanded anger, while Beelzebub reigned over gluttony, *Leviathan* over envy and *Belphegor* over indolence. Was humankind fomenting its own fears, like children, just for the thrill of it? Since devils grew uglier with every evil act, one might have expected their accumulated deformities to be repellent. No such thing. The masses demanded to see them again and again. The most admired figures in the Mystery plays were not Adam and Eve in their immaculate nudity, not the saints in their gilded robes, nor even the Virgin herself. They were Satan and his cohorts of shaggy demons emerging from the vast maw of Leviathan in a heartening blaze of eternal flame. The He-Goat, mount of Dionysos and Aphrodite, and an object of adoration in Egypt often confused with the Greek *Pan*, was, in medieval times, the incarnation of perversion and insatiable lubricity. For witches and sorcerers, the He-Goat was none other than the Anti-Christ, the standard-bearer of the poor man's rebellion; they humbly kissed its anus in derisive worship, and risked being burnt at stake by the Inquisition for their pains. But the artists of the early Renaissance sought to transform the stinking beast into an amiable satyr, a gallant faun. In his *Ensayos*, Goya even awarded him an air of grandeur, a majestic and sometimes learned appearance. Satan, the master of metamorphosis, has always known how to adapt to the times. He is at his most formidable, he believes, when he can seduce rather than terrify … So the spikes, the scales and the bellies opening into a terrifying maw were consigned to history. Now the charming fauns and satyrs of mythology were revisited in the athletic devils of Michelangelo and Signorelli. In Poussin, Boucher and the *peintres pompiers*, Satan became the distinguished master of a distinguished ceremony, the Sabbath. For Voltaire's corrosive laughter had, along with the philosophers and atheists, made the Devil so much more approachable and decorous, in a word, so much more human. Was this another of Old Nick's ruses? Modern art, said Baudelaire, had »an essentially demonic tendency … as if the Devil amused himself fattening up the human race in his poultry yard to make his diet the more succulent«. The Devil appears incognito in the magic lanterns of television. We no longer recognise him. But we higher animals can hardly be satisfied with a ›heaven devoid of hope‹, with a truce in the struggle of Good and Evil. We know, in our innermost hearts, that only Pan's repentant tears can extinguish the flames of Hell. In the jargon of the age, we again rise up and proclaim: »Make love not war«.

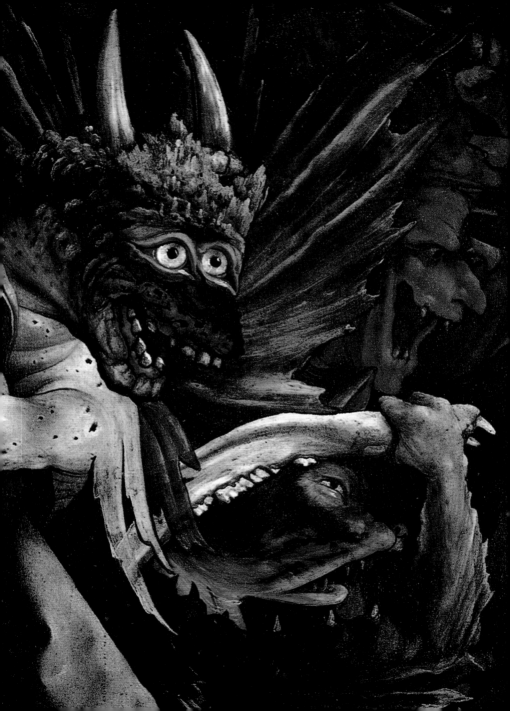

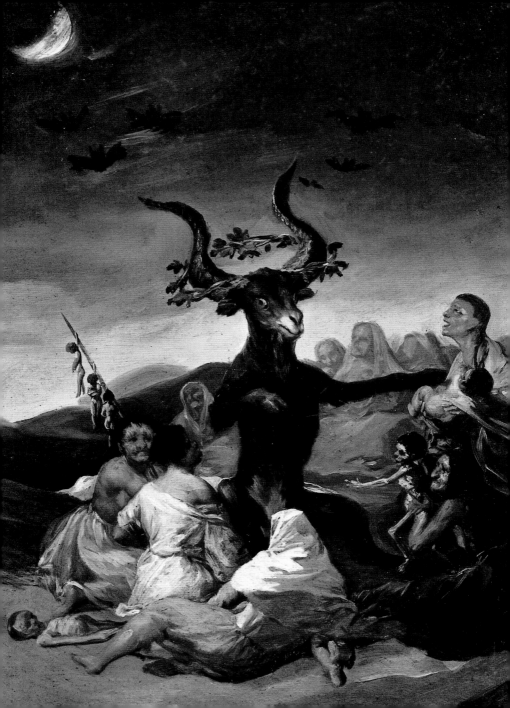

Luzifer und seine Gesellschaft

Die alten Römer und Griechen bezeichneten ihn als *Diabolus* oder *Diabolos*, den Verleumder. In der klassischen Mythologie nannte man den Geist des Bösen, den schlechten Genius, nach dem griechischen Wort *daimon* einen Dämon. Die Hölle kannte man schon seit langem, in Ägypten, Assyrien, Israel, Etrurien und dem Fernen Orient, überall dort, wo das Prinzip der Bestrafung von Übeltätern galt. Der Glaube lehrt, dass Gott die Engel als reine und gute Wesen schuf und sie dann einer Prüfung unterzog. Die einen gingen daraus als Sieger hervor, die anderen widersetzten sich und wurden zu Höllenqualen verurteilt: Das sind die gefallenen Engel, die Teufel und Dämonen. Sie alle gehorchen einem Herrn, dem *Teufel*, auch bekannt unter den Namen *Satan* (was der Feind oder der Böse bedeutet), *Luzifer* (der Lichtbringer), *Arareth, Beelzebub* und vielen anderen. Selbst wenn die gefallenen Engel ihre Gnade verloren haben, behielten sie doch einen Teil jener Begabungen, durch die die engelhafte Natur der menschlichen überlegen ist. Sie üben weiterhin ihre – unheilvolle – Macht aus, führen die Menschen in Versuchung und setzen alles daran, sie zum Bösen zu bewegen. Mit Besessenheit und Leidenschaft können sie tiefe Verwirrung in das menschliche Dasein bringen. Dabei haben sie eine so große Macht über die materielle Natur, dass sie sogar Wunder bewirken können. Es verwundert nicht, dass es – außer der Frau – keine andere Gestalt in der Kulturgeschichte gibt, die die Fantasie der Künstler mehr angeregt hätte als die des Teufels. Die Verkörperung des Bösen tritt in den vielfältigsten Erscheinungen und Personifikationen auf: als Schlange oder Kröte, Gott oder Göttin der Antike, Monster oder Fabelwesen. Der geläufigste Typus hat sich im 12. Jahrhundert herausgebildet: eine menschliche Gestalt, jedoch vollständig behaart, mit spitz zulaufenden Ohren und gespaltenen Klauen, dem Bocks- oder Pferdefuß. Diese Gestalt trägt Hörner und einen langen Schwanz. Die Fledermausflügel, mit denen Giotto, Hieronymus Bosch oder Botticelli ihre Dämonen ausgestattet haben, stammen von chinesischen Malereien im Stil der Rollbilder von Li Long Mien. Die Hörner und Hufe Satans verraten einen mediterranen Ursprung: *Pan, Dionysos* und die *Satyrn* trugen diese Attribute, die wiederum von bestimmten Götzenfiguren des Paläolithikums entlehnt sind. Solchen Traditionen entspringen die Ähnlichkeiten von Genien des assyrisch-baylonischen Pantheons mit den Wasserspeiern unserer Kathedralen oder von Khmer-Masken mit den grotesken Dämonen bei Grünewald und Callot. Auch die Verdrehung und Verrenkung der Körper wie bei Goya und Picasso findet sich bereits in Skulpturen aus dem alten Mexiko. Jean Wier,

ein Dämonologe aus dem 16. Jahrhundert, zählte 72 Fürsten und 7 405 926 Dämonen – »alle schändlich«. Die Künstler wiesen dem Teufel eine Hauptrolle in der Darstellung des Jüngsten Gerichts zu, wo die Seelen gewogen und anschließend die Verdammten mit ebenso vielfältigen wie einfallsreichen Strafen belegt werden. Im 16. Jahrhundert kam Bischof Pierre Binsfeld auf die glorreiche Idee, um Ordnung und Methode in die Sache zu bringen, jeder Kapitalsünde einen Dämon zuzuordnen. *Luzifer* wachte fortan über den Stolz, *Mammon* über die Habgier und *Asmodi* über die Wollust. *Satan* herrschte über Zorn und Wut, während *Beelzebub*, *Leviathan* und *Belphegor* die Unmäßigkeit, den Neid und die Eitelkeit zu ihren Herrschaftsgebieten erhoben. Der »Große Ziegenbock«, das Reittier von Aphrodite und Dionysos, das einst in Ägypten so verehrt wurde und häufig mit dem Gott *Pan* der Griechen verwechselt wird, verkörperte im Mittelalter den Inbegriff von Perversion und unersättlicher Lüsternheit. Für Hexen und Hexer war er nichts anderes als der Antichrist, auch wenn sie dafür riskierten, von einer erbarmungslosen Inquisition bei lebendigem Leib verbrannt zu werden. Für sie war er der Anführer eines Aufstands der Armen gegen die Wohlhabenden, dem sie devot den Hintern küssten, natürlich als Zeichen des Spotts. Doch die Künstler der Frührenaissance verwandelten das stinkende Tier schon bald in einen liebenswerten Satyr oder einen galanten Faun. Goya verlieh ihm später in seinen *Ensayos* sogar etwas Grandioses, eine majestätische und manchmal gelehrte Pose. Als Meister der Metamorphose hat es Satan immer verstanden, sich den wechselnden Moden anzupassen. Er wusste, dass er niemals so furchterregend war wie in seiner Rolle als Verführer. Folglich sind die Stacheln, die Schuppen und die Bäuche, auf denen die klaffenden Mäuler sitzen, zu dekorativem Beiwerk verkommen. Mit seinen athletischen Erscheinungen bei Michelangelo oder Signorelli kehrte er zurück zum zauberhaften Reiz der Faune und Satyrn aus der Mythologie. Mit Poussin, Boucher und den »Pompiers« wird der Sabbat zu einem Festtag, an dem Satan den vorzüglichen Zeremonienmeister gibt. Erst das Lachen Voltaires, der Philosophen und Atheisten hat uns den Teufel wieder näher gebracht, hat ihn für uns menschlicher, einschätzbarer werden lassen. Oder ist es eine neue List, dass sich der Teufel auf diese Weise fast menschengleich gemacht hat? Die moderne Kunst hat – nach den Worten Baudelaires – »eine zutiefst dämonische Tendenz …, als hätte der Teufel seine Freude daran gefunden, das Menschengeschlecht auf seinem Hühnerhof fett zu mästen, um sich eine üppigere Mahlzeit zubereiten zu können«. Inkognito taucht er heute in den magischen Fensterluken der Fernseher auf. Man kann ihn nicht mehr erkennen. Doch als höhere Lebewesen können wir uns nicht mit einem »hoffnungslosen Himmel« zufrieden geben, den Kampf um Gut und Böse aufgeben. Im tiefsten Inneren wissen wir, dass einzig Pans Tränen der Reue das Höllenfeuer löschen könnten. Oder zeitgemäßer ausgedrückt, wir wagen die Auflehnung und rufen: »Make love, not war!«

H. R. Giger *Baphomet (after Eliphas Lévi)*, 1975

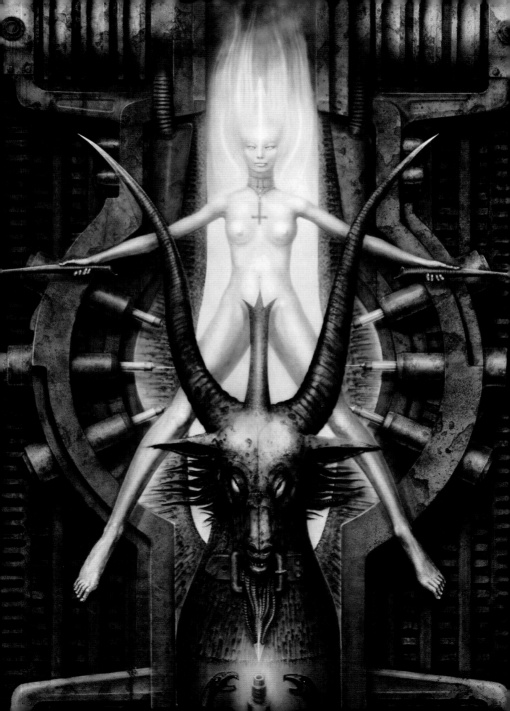

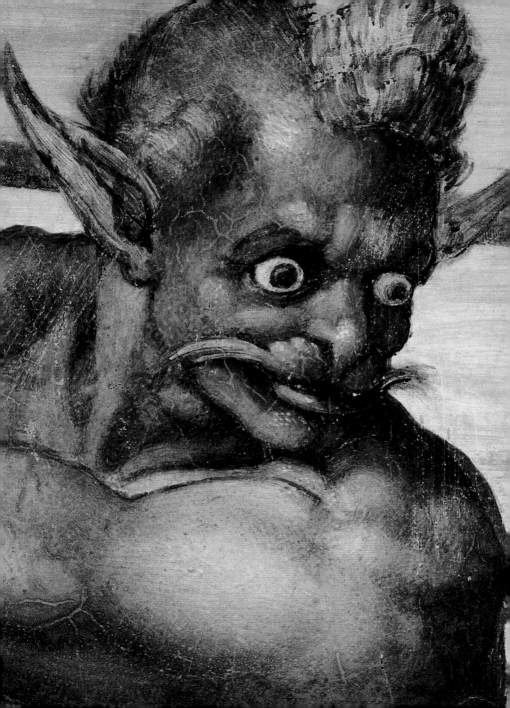

Lucifer et Compagnie

Les Romains l'appelaient *Diabolus*, et, avant eux, les Grecs, *Diabolos*, le calomniateur. Dans la mythologie classique, on appela cet esprit du mal, ce mauvais génie *Dèmon*, d'un mot grec (*Daimôn*). Les Enfers existaient depuis longtemps, en Egypte, en Assyrie, en Israël, en Etrurie, en Extrême-Orient, partout où l'on admettait le principe, assez vague d'ailleurs, de la punition des méchants. La foi enseigne que Dieu créa les anges purs et bons, mais qu'il les soumit à une épreuve. Les uns en sortirent vainqueurs, les autres résistèrent et furent condamnés aux supplices de l'Enfer : ce sont les anges déchus, les diables et les démons. Ils obéissent à un chef, le *Diable*, que l'on désigne souvent par les noms de *Satan* (c'est-à-dire l'ennemi ou le mauvais), *Lucifer* (le brillant), *Arareth, Belzébuth*, etc. Mais, en perdant la grâce, les anges déchus conservèrent néanmoins une partie des dons qui rendent la nature angélique supérieure à la nature humaine. Ainsi sont-ils encore capables d'exercer leur puissance – maléfique – dans le monde. Ils tentent les hommes et s'efforcent de les porter au mal. Ils peuvent jeter un trouble profond dans les facultés humaines par l'obsession et la passion. Ils ont un pouvoir sur la nature matérielle, au point de générer des prodiges. Il n'est pas étonnant, dès lors, qu'il n'y ait pas de figure, à part celle de la femme, qui ait plus prêté à l'imagination des artistes que celle du Diable. L'incarnation du Mal apparaît sous les figurations les plus variées : serpent, crapaud, dieux et déesses antiques, monstres, animaux fabuleux … Le type le plus courant s'est fixé vers le 12e siècle. Il a une forme humaine, le corps velu, les oreilles pointues, les pieds fourchus. Il porte des cornes et est pourvu d'une longue queue. Les ailes de chauve-souris, dont Giotto, Bosch ou Botticelli ont affublé leurs démons, proviennent des peintures chinoises dans le style des rouleaux de Li Long Mien. Les cornes et les sabots de Satan trahissent une origine méditerranéenne : *Pan, Dionysos* et les *Satyres* portaient ces attributs, eux-mêmes empruntés à certaines figures sacrées du paléolithique … Une véritable tradition de la forme démoniaque rapproche ainsi les génies du panthéon assyro-babylonien des gargouilles de nos cathédrales, et les masques Khmers des grotesques de Grünewald et de Callot. De même, la dislocation des corps, chère à Goya ou à Picasso, apparaît déjà dans la sculpture de l'ancien Mexique. Jean Wier, démonologue du 16e siècle, comptait 72 princes et 7 405 926 démons « tous immondes ». Le rôle favori du Diable étant, relayé par les artistes, de jouer les vedettes dans les scènes de Jugement dernier où l'on pèse et s'arrache les âmes, et dans les châtiments multiples et inventifs par lesquels on punit les damnés. Au 16e siècle, un beau souci

Michelangelo The mythological figure *Charon* forcing the Damned to cross the Styx. Detail of *The Last Judgement*, 1537–1541. Rome, Palazzi Vaticani, Cappella Sistina

d'ordre et de méthode devait inciter l'évêque Pierre Binsfeld à attribuer un démon à chacun des péchés capitaux. *Lucifer* veillait ainsi sur l'orgueil, *Mammon* sur l'avarice et *Asmodée* sur la luxure. *Satan* gouvernait la colère, tandis que *Belzébuth, Léviathan* et *Belphégor* régnaient sur la gourmandise, l'envie, la paresse. Comme les enfants, les hommes joueraient-ils à se faire peur ? On aurait pu croire que la difformité et la laideur des diables augmentant à la mesure de leurs forfaits, elles auraient répugné et éloigné les spectateurs. Il n'en est rien, cette laideur plaît aux masses populaires qui ne cessent d'en réclamer le spectacle. Les personnages les plus admirés au cours des mystères ne sont pas Adam et Eve dans leur nudité, ni les saints aux robes dorées, voire la Vierge Marie, mais bel et bien Satan et sa cohorte de démons hirsutes, s'échappant de l'énorme gueule du Léviathan, d'où sortent les si jolies flammes infernales. Monture d'Aphrodite et de Dionysos, jadis adoré en Egypte et fréquemment confondu avec le *Pan* des Grecs, le *Grand Bouc* incarnait au Moyen-Age l'image même des perversions et d'une insatiable lubricité. Pour les sorciers et les sorcières, au risque d'être brûlés vifs par une Inquisition impitoyable, le *Grand Bouc* n'était autre que l'Antéchrist, le porte-drapeau de la révolte des pauvres contre les nantis, dont ils embrassaient l'anus dévotement, en signe de dérision. Mais les artistes du début de la Renaissance se chargèrent bientôt de transformer l'animal puant en un satyre aimable, en un faune galant,Goya lui conférant même un air de grandeur, une allure majestueuse et parfois docte dans ses *Ensayos*. Satan, maître des métamorphoses, a toujours su s'adapter à la mode changeante. Il sait qu'il n'est jamais plus redoutable que lorsqu'il séduit au lieu de faire peur … Relégués, donc, au rang d'accessoires, les piquants, les écailles et les ventres qui s'achèvent par des gueules béantes. Retour au charme des faunes et des satyres de la mythologie, via l'apparence athlétique chère à Michel-Ange ou à Signorelli. Avec Poussin, Boucher ou les « Pompiers », le Sabbat deviendra même une fête dont Satan sera le distingué maître de cérémonie. C'est que l'éclat du rire de Voltaire, des philosophes et des athées a rendu le Diable plus proche, plus humain, plus fréquentable. Est-ce par une nouvelle ruse que le Diable s'est ainsi fait homme ? L'art moderne, prophétisait Baudelaire, « a une tendance essentiellement démoniaque … comme si le Diable s'amusait à engraisser le genre humain dans ses basses-cours pour se préparer une nourriture plus succulente ». Il apparaît incognito aux lucarnes magiques des télévisions. On ne peut plus le reconnaître. Mais les animaux supérieurs que nous sommes ne sauraient cependant se satisfaire d'un « ciel vide d'espoir », de l'abandon de la lutte du Bien et du Mal, et savent, au plus profond d'eux-mêmes, que seules les larmes de repentir de Pan pourront éteindre les flammes de l'Enfer … En termes plus modernes, ils osent se révolter et proclamer : « Faites l'Amour et pas la Guerre ».

Michelangelo The mythological figure of *Minos*, judge of the Underworld. Detail of *The Last Judgement*. 1537–1541. Rome, Palazzi Vaticani, Cappella Sistina. Michelangelo gave him the face of Biagio da Cesena, master of ceremonies for the pope, who was among the first, says Vasari, to be scandalised by »so many indecent nudes, showing their shameful parties.«

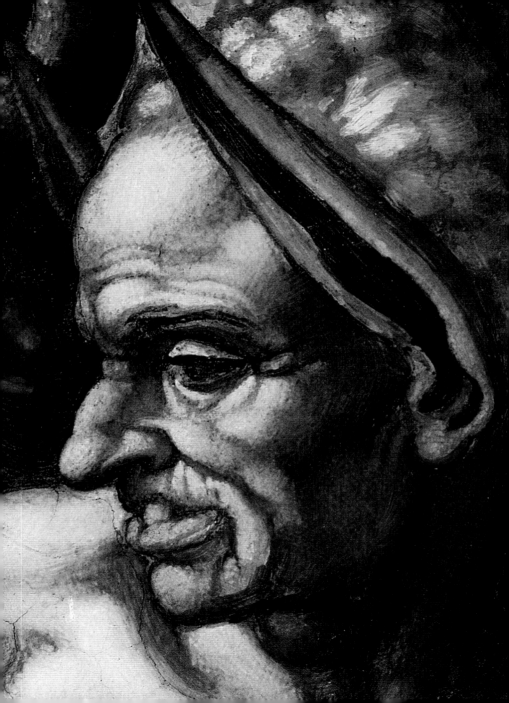

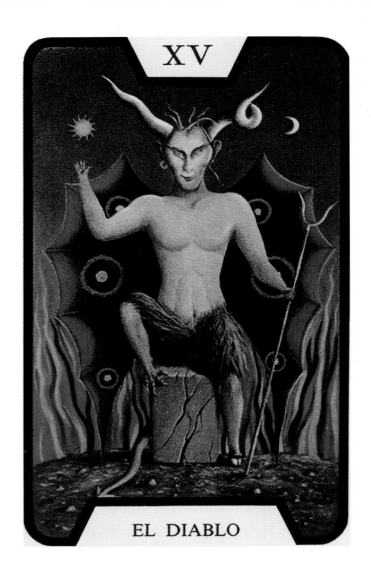

The Devil. Spanish Tarot card, 19th c.

The Beauty of the Devil

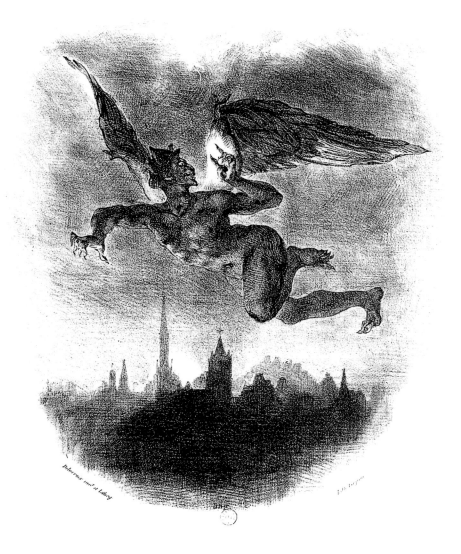

Eugène Delacroix *Mephistopholes in the Air.* Illustration for Goethe's *Faust.* Lithograph, 1828.
Paris, Musée Eugène Delacroix

Antoine Wiertz *Satan, Angel of Evil*. Detail of the triptych *Christ in the Tomb*, 1839.
Brussels, Musées royaux des Beaux-Arts, Musée Wiertz

Michelangelo *Head of a Satyr*, c. 1506. Paris, Musée du Louvre

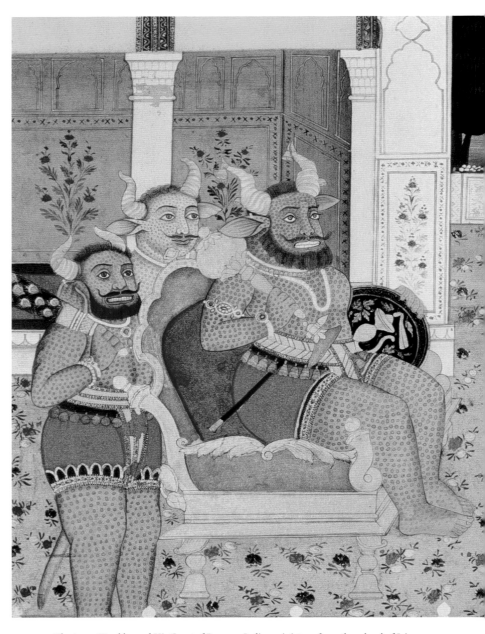

The Asura Kumbha and His Court of Demons. Indian miniature from the school of Jaipur,
the city which appears in the background, c. 1800

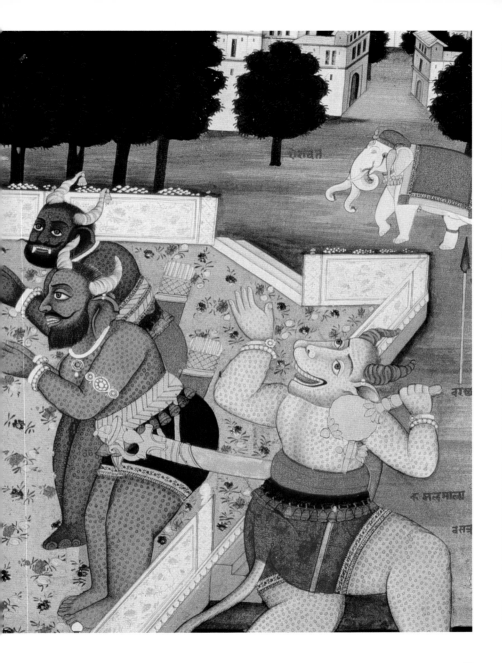

▲ *The Devil.* Character of the Paris Carnival, 19th c.
◄ *The Devil.* Illustration from the treatise *Compendium maleficarum* by Francesco Maria Gnazzo,
Milan 1608

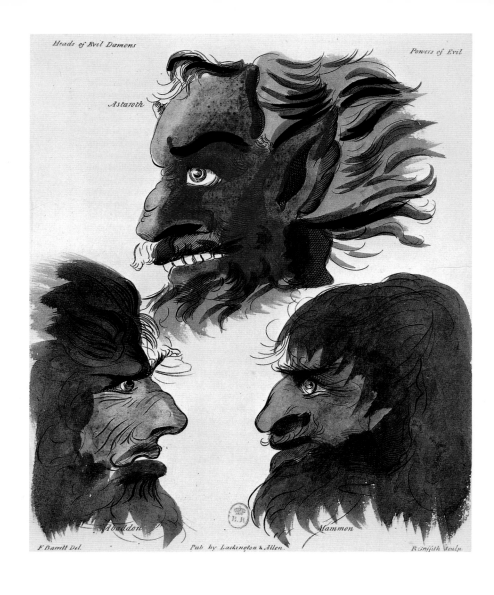

Astaroth, Abaddon, and Mammon. Three of the main demons, reproduced in
Francis Barrett's *The Magus.* London 1801

The Devil of the Cathedrals. Stone, Middle Ages. Autun, cathedral 25

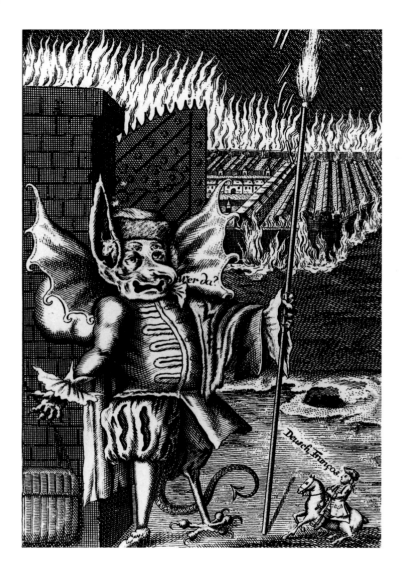

Johann Joachim Püschel (German engraver) *The Keeper of the Infernal City*, c. 1755.
Paris, Bibliothèque des Arts décoratifs

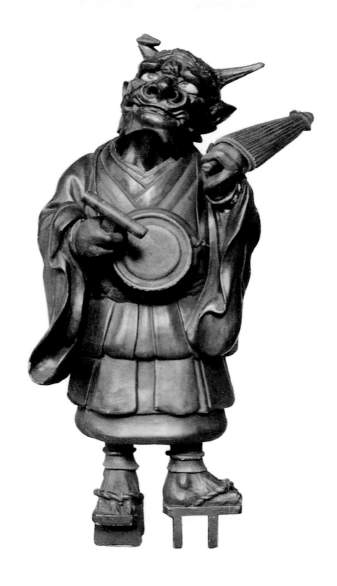

Japanese demon, 18th c. Paris, Musée Guimet

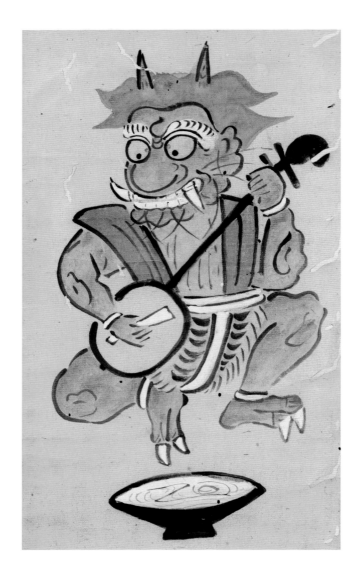

Demon by an unknown Japanese artist. Kakemono scroll painting, 18th c.

Demon by an unknown Turkish artist, 15th c. Istanbul, Topkapi Museum

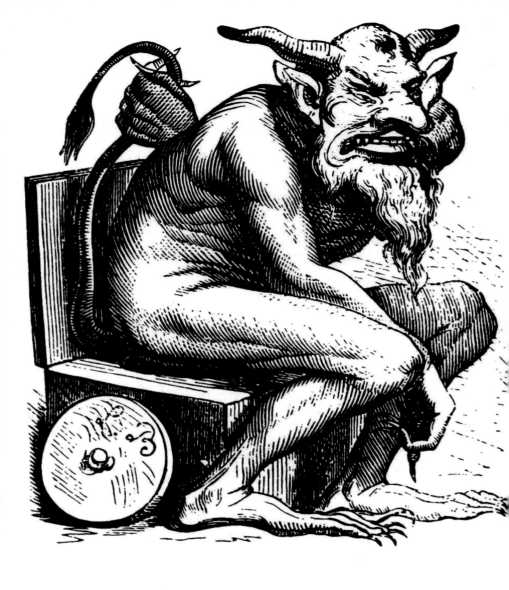

The Devil. Romantic period, c. 1760–1830

The Devil. Head of a wooden puppet from the Jardin des Tuileries puppet show, 20th c.
Paris, Musée national des Arts et Traditions populaires

▲ *The Devil*. Popular art sculpture, originating from an itinerant barrel-organ from the 19th c.

▸ **Pierre & Gilles** *Thierry Mugler as Devil*, 1992

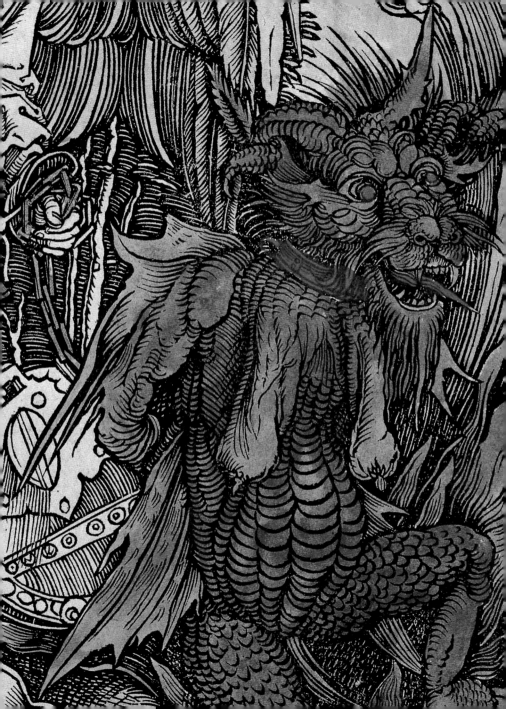

▴ **Félix Labisse** *Asmodeus, Balaam and Astaroth*, 1975
◂ **Albrecht Dürer** *The Devil*. Detail of the woodcut series of *The Apocalypse*, 1498

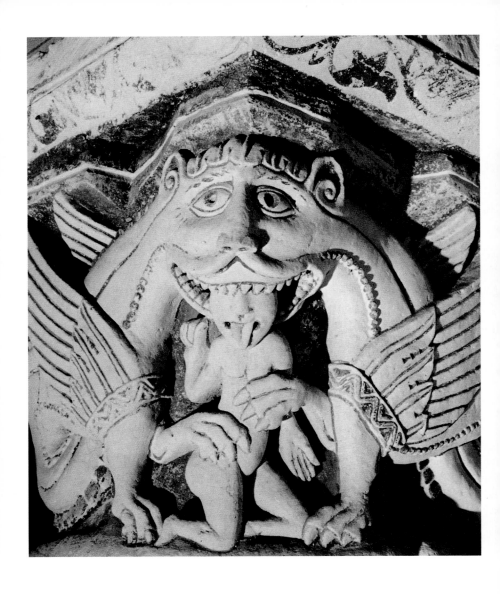

▲ *The Mouth of Hell*. Middle Ages, carved outside the church Saint-Pierre. Chauvigny, France
▸ **Matthias Grünewald** *The Devil Breaking a Window with Fury and Spitting Fire.*
Detail of the *Isenheim Altarpiece*, c. 1512–1516. Colmar, Musée d'Unterlinden

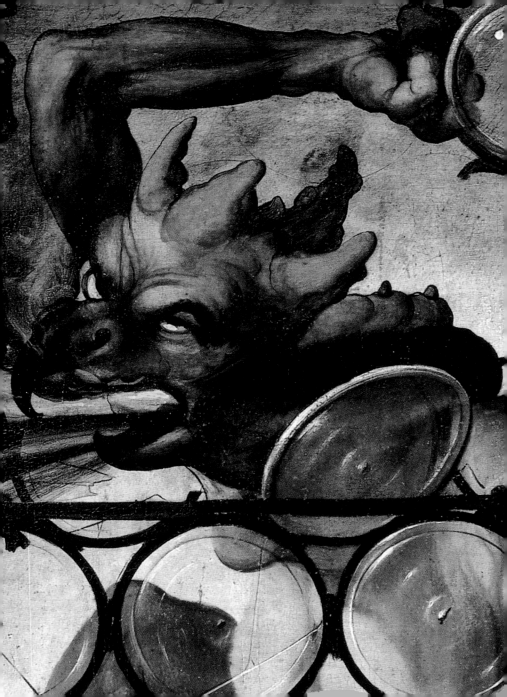

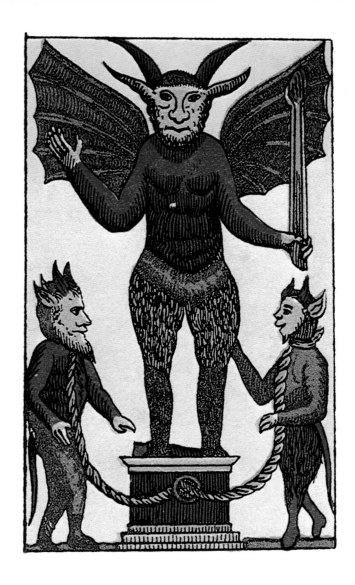

The Devil and His Two Acolytes. Tarot card, 19th c.

The Devil and His Two Acolytes. Tarot card, 18th c.

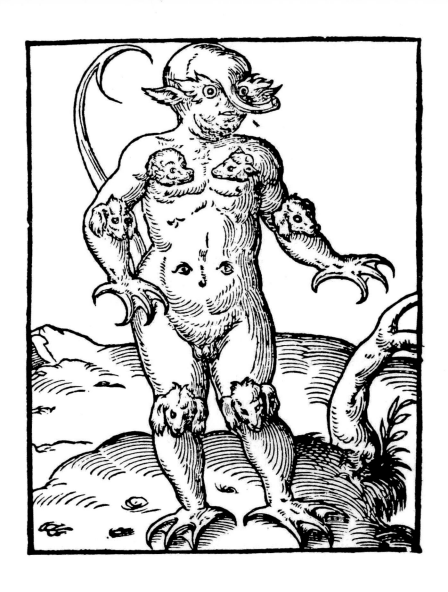

▲ Can the Devil multiply? Grave question in the 15th c.!
This monster being a possible result. Popular etching
▶ *Fil au Démon*. Lithograph, c. 1880–1890. Paris, Bibliothèque des Arts décoratifs.
Satan rediscovered by advertising.

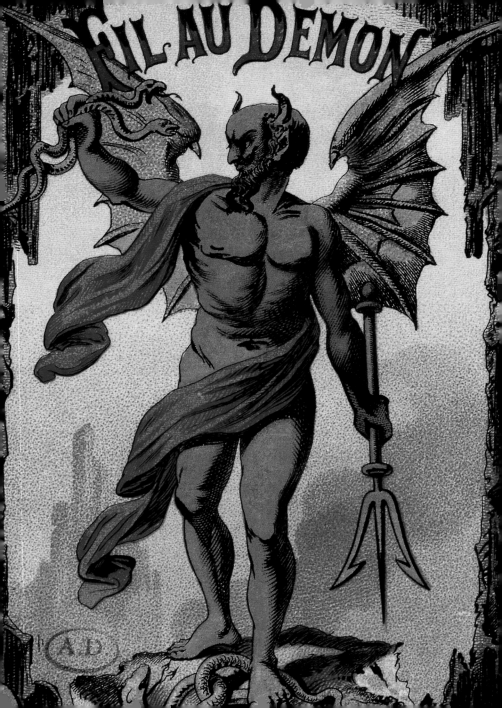

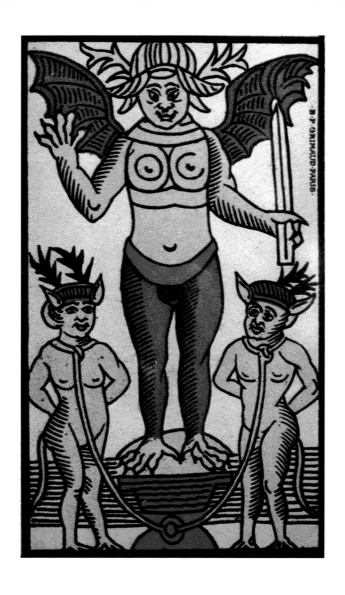

The Devil of the Tarot de Marseille. 17th c. Paris, Bibliothèque Nationale.
He holds the lit torch, symbol of black magic and of destruction.

▲ **Karol Baron** *Incubus and Vampire*. Watercolour, 1970. Private collection
▶▶ **Aubrey Beardsley** Frontispiece from *Salomé*, 1893 and *Dancing Faun*, 1894 43

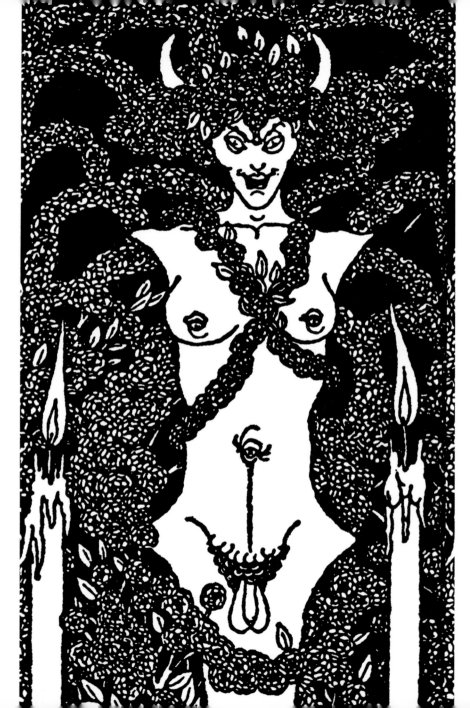

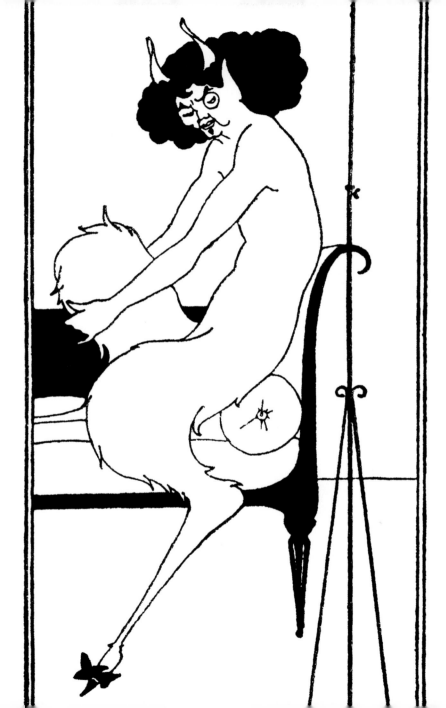

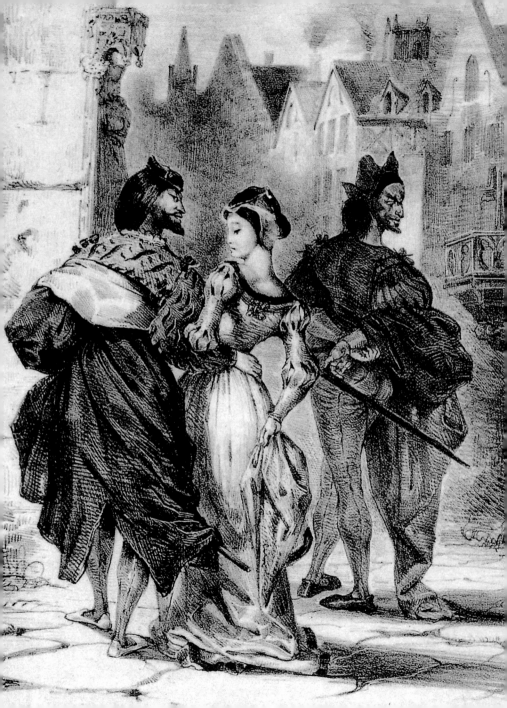

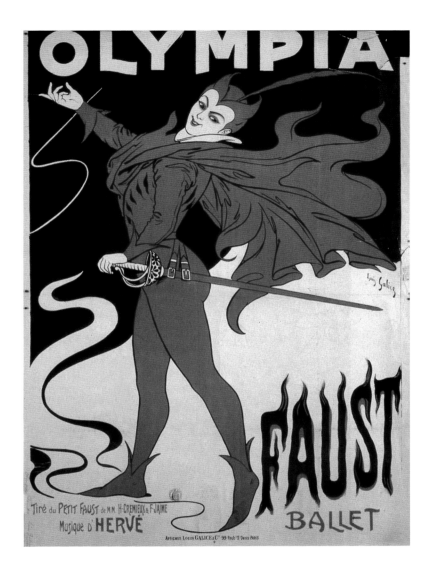

▲ **Louis Galice** *The Devil* as a publicity and theatrical agent.
Litho poster for the ballet *Faust* at the Olympia, c. 1900. Paris, Musée de la Publicité
◄ **Eugène Delacroix** *Mephistopheles,* promoting the love affair between Faust and Margaret.
Illustration for Goethe's *Faust*. Lithograph, 1828. Paris, Musée Eugène Delacroix

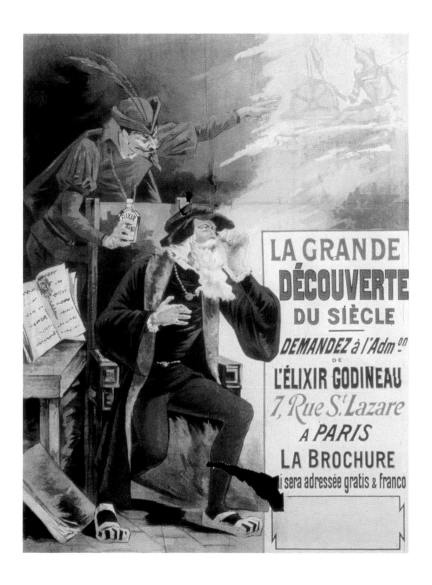

▴ *The Devil and Faust*, helping to extend life thanks to the Godineau elixir (détail).
Litho poster, c. 1900. Paris, Musée de la Publicité
▸ *Les Dante*, diabolic act at the Folies-Bergère. Litho poster, c. 1900.
Paris, Musée de la Publicité

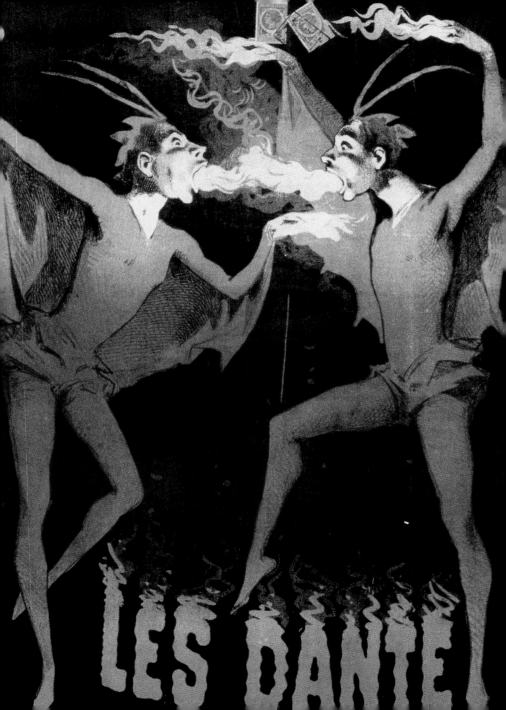

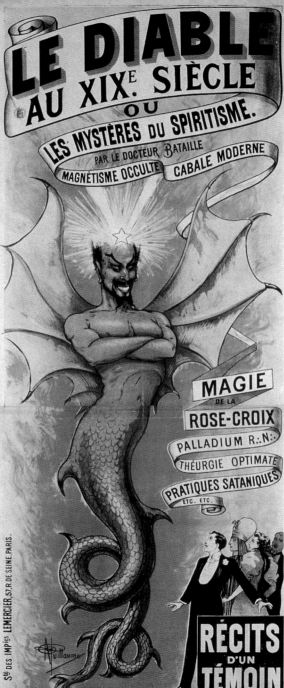

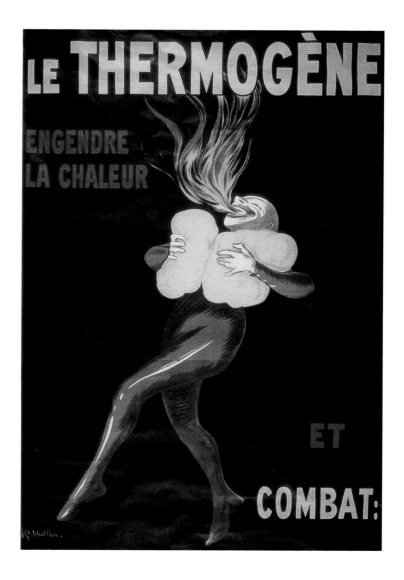

▲ **Leonetto Cappiello** *The Thermogène Breeds Heat.* Litho poster (détail), 1907.
Paris, Musée de la Publicité
◄ **Albert Guillaume** *The Devil in the 19th c. or The Mysteries of Spiritism.*
Litho poster, end of 19th c. Paris, Musée de la Publicité

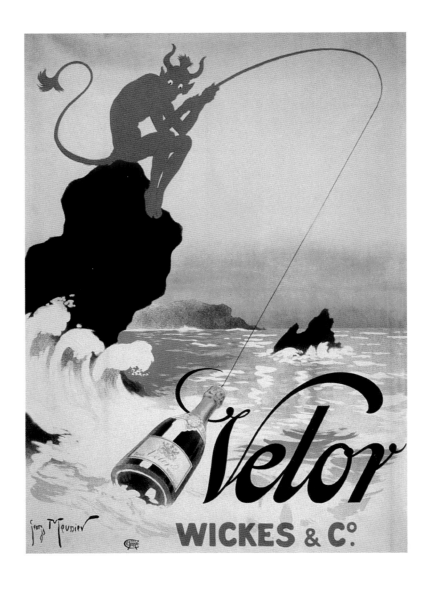

Georges Meunier *Advertisement for Wine*. Litho poster, 1898. Paris, Musée de la Publicité

T. T. **Heine** *Advertisement for Ink*. Litho poster, 1897. Paris, Musée de la Publicité 53

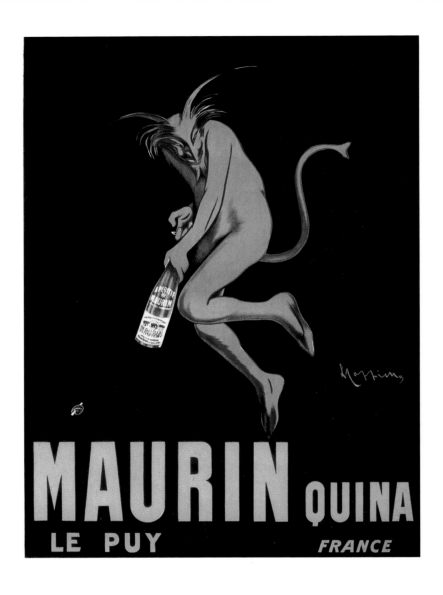

Leonetto Cappiello *The Devil Selling an Aperatif*. Litho poster, 1906.
Paris, Musée de la Publicité

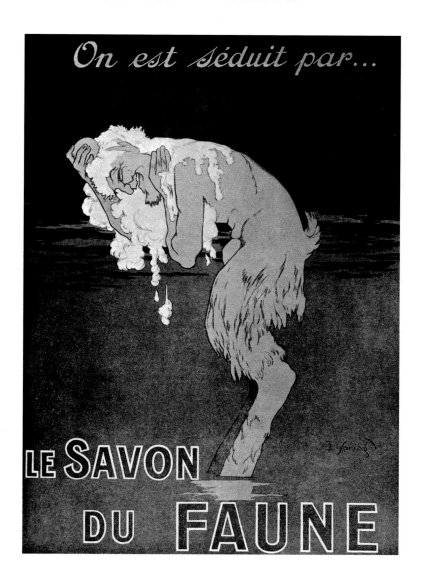

Faun giving an example of cleanliness contrary to his reputation.
Advertisement for Soap. Litho poster. France, c. 1893

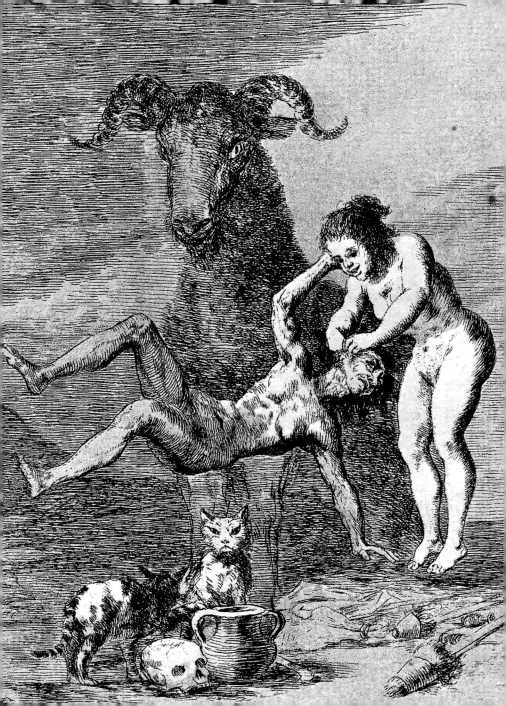

The Sabbath of the He-Goat

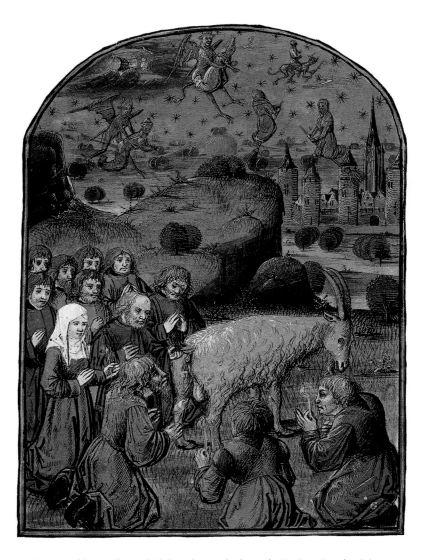

▲ *Adoration of the Devil's Ass* which has taken on the form of a He-Goat. French miniature
from Johannes Tinctor's *Tractatus contra sectam Valdensium*, 15th c. Paris
◄ **Francisco de Goya** *Trials. Caprichos No 60*, 1796/97 57

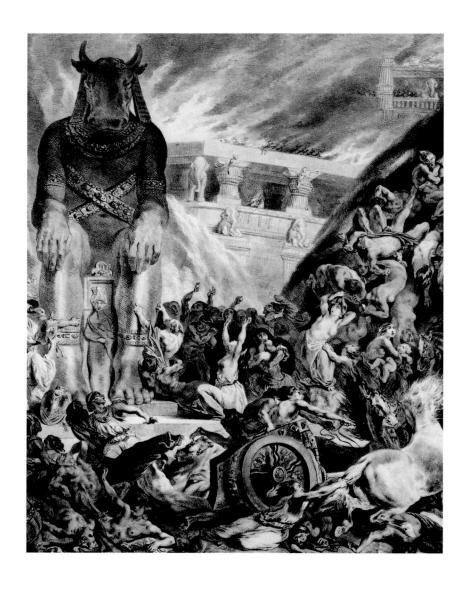

Bieslange *Punishment by Fire*. Etching prefiguring the »Preplums« of Hollywood, 1897
Paris, Bibliothèque Nationale

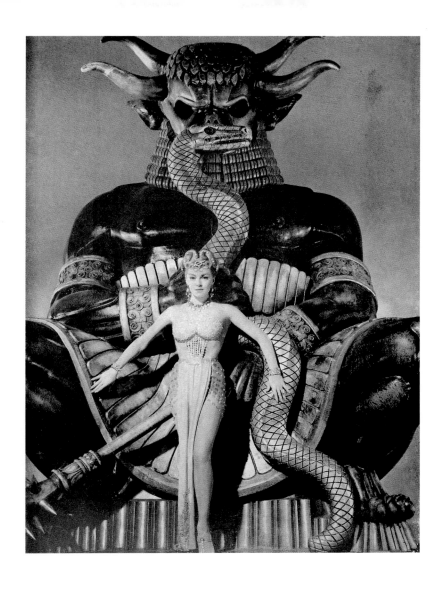

Satan in Hollywood or »The Beauty and the God Baal«
… and what remains of the myth in the 20th century.

▲ **Louis Breton** *The Demon's Favourite.* Engraving from the *Dictionnaire Infernal*
by Collin de Plancy, 1863
▶ *Satyr and the He-Goat.* Marble from Herculaneum, before 79 BC. Naples, Museo Nazionale

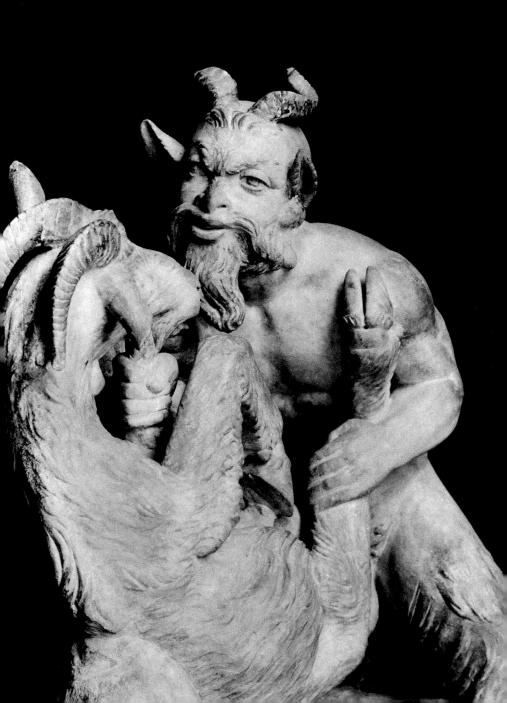

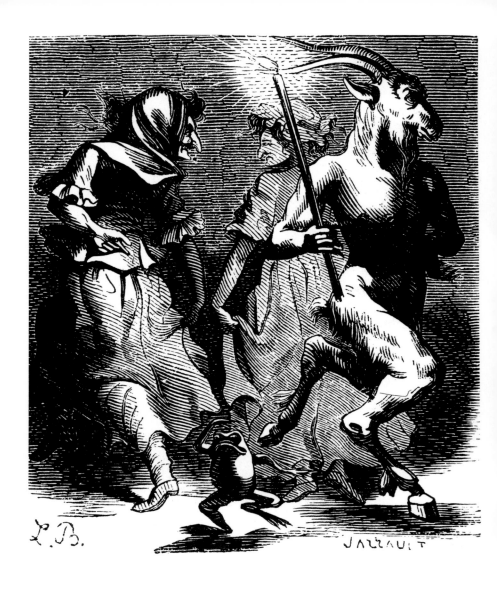

Louis Breton *The He-Goat Opens the Sabbath.*
Engraving from the *Dictionnaire Infernal* by Collin de Plancy, 1863

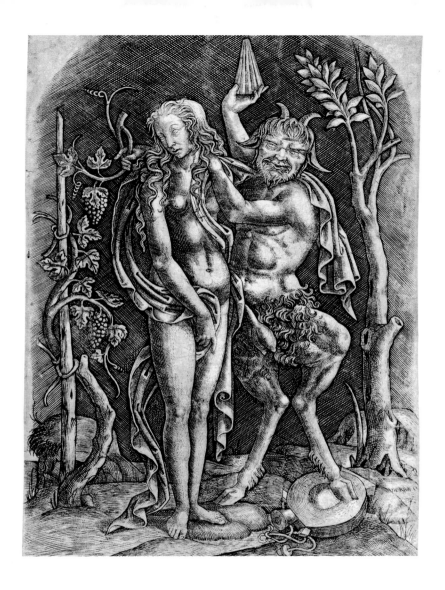

Satyr and Bacchante. Italian engraving, 16th c. Paris, Bibliothèque Nationale 63

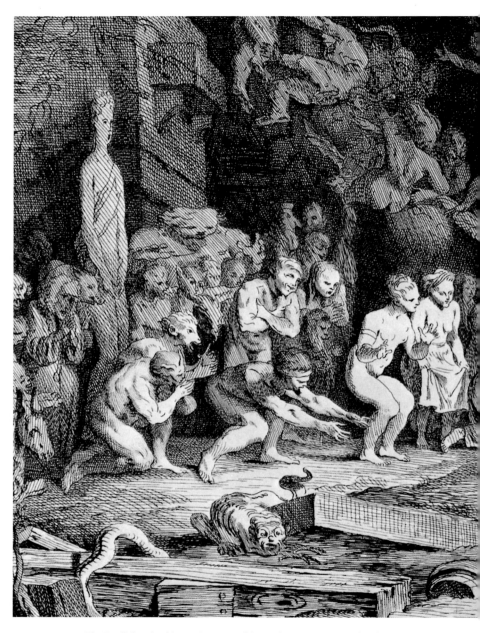

The Devil showing his He-Goat ass to his worshippers to receive their homage.

Etching by Comte de Caylus after a drawing by Claude Gillot, 18th c. Paris, Bibliothèque Nationale

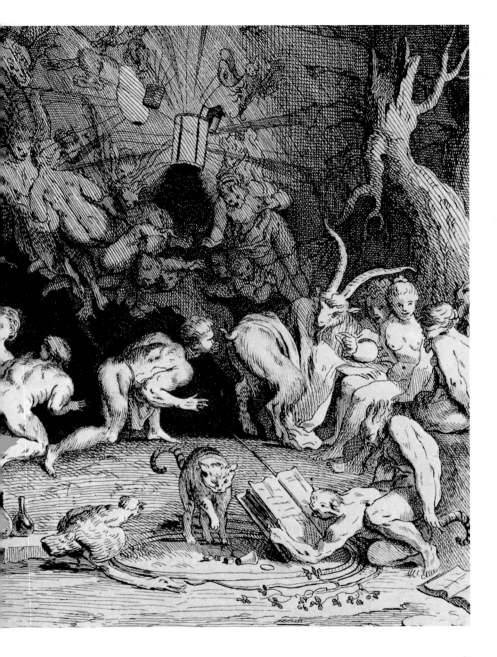

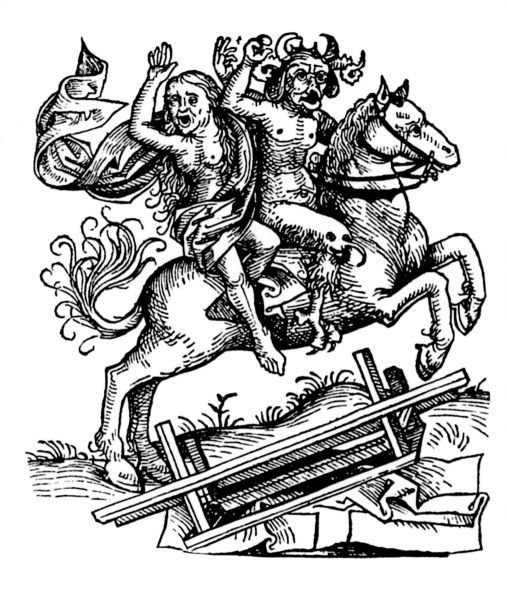

The Demon Carrying a Witch on His Horse. Woodcut from Hartmann Schedel's
Chronica mundi. Nuremberg, 1493

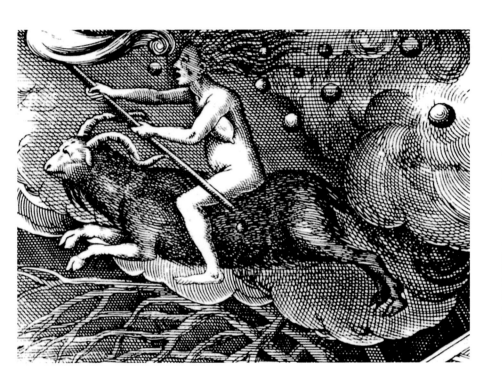

Pieter Bruegel the Elder *A Witch Crossing the Sky on the Back of a He-Goat* (detail).
Engraved by Hieronymus Cock, 16th c. Paris, Bibliothèque Nationale 67

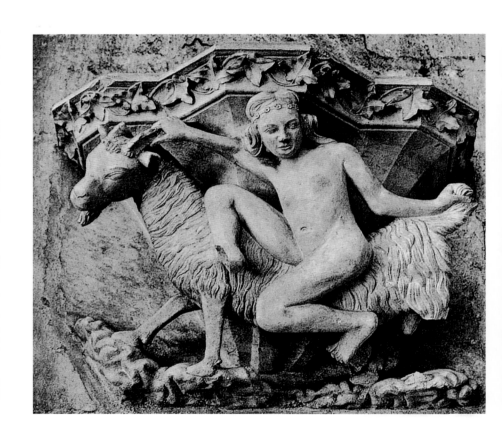

Lechery. Marble console, mid 14th c. Auxerre, cathedral

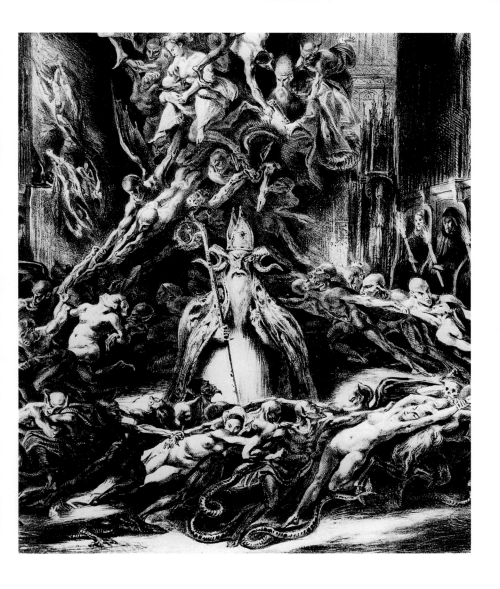

Louis Boulanger Illustration for the poem *La Ronde du Sabbat* (detail)
by Victor Hugo, 1832. Paris, Musée Victor Hugo

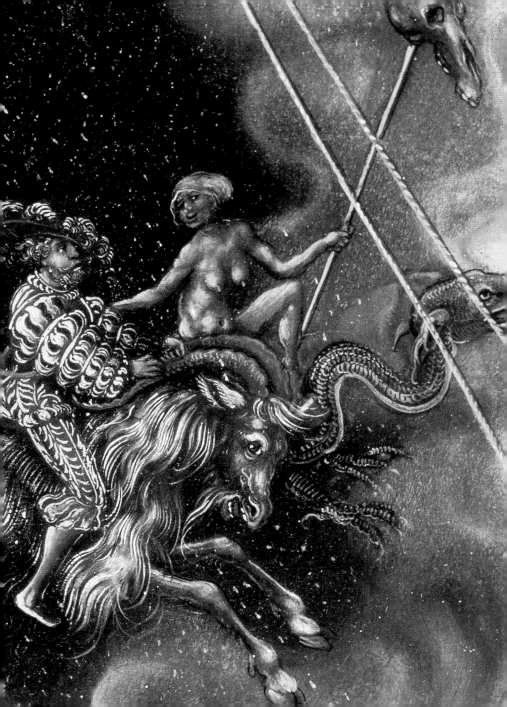

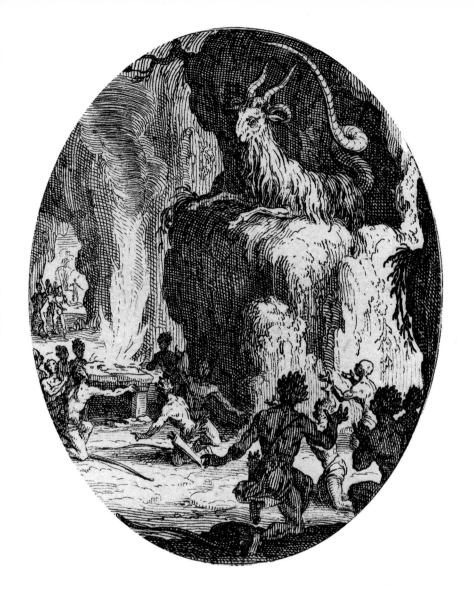

▴ Jacques Callot *The Goat of the Demon*. Etching, 1627. Paris, Bibliothèque Nationale
◂ Lucas Cranach the Elder *Ride to the Sabbath*. Detail of *The Melancholy*, 1532.
Colmar, Musée d'Unterlinden

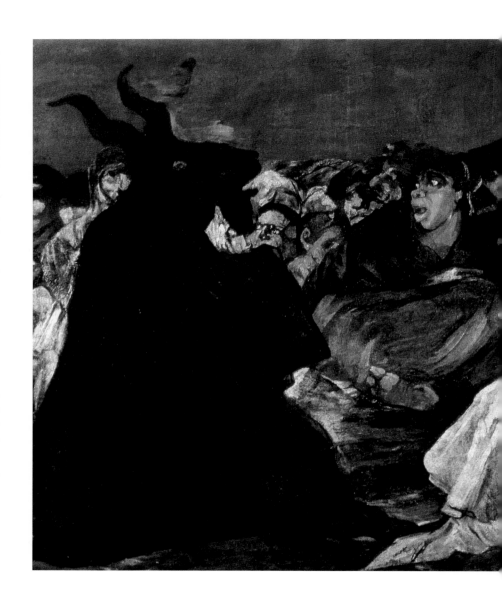

Francisco de Goya *The Witches' Sabbath* (detail), 1820–1822. Madrid, Museo del Prado.
One of the fourteen »Black Paintings« from his home, called the Quinta del Sordo.

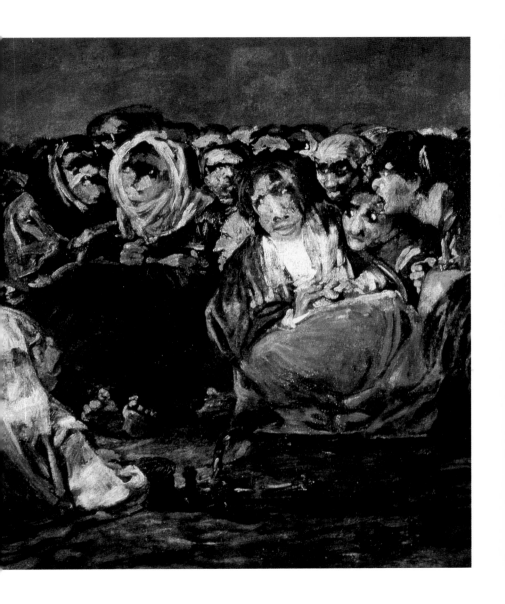

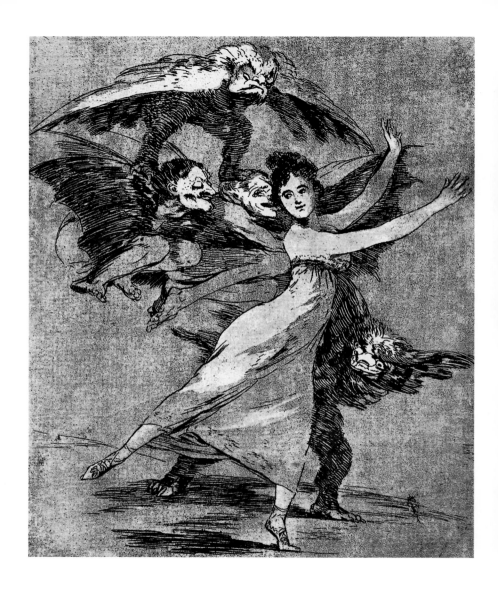

Francisco de Goya *You Will Not Escape. Caprichos No 72*, 1796/97

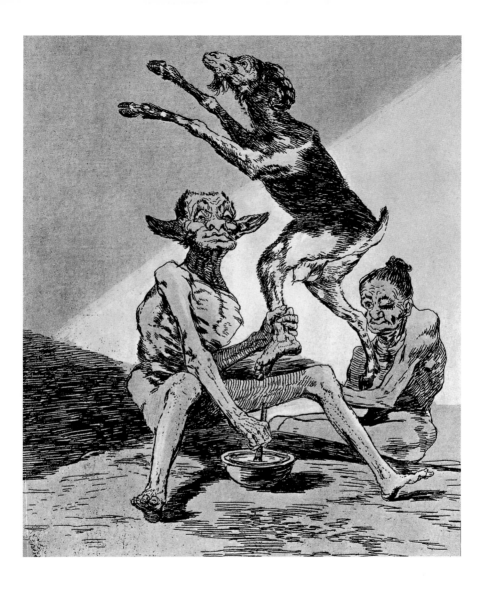

Francisco de Goya *Wait till You've Been Anointed. Caprichos No 67*, 1796/97

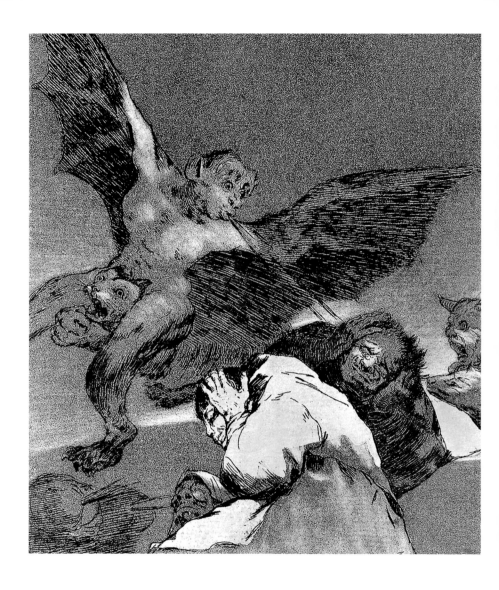

Francisco de Goya *Tale Bearers – Blast of Wind. Caprichos No 48*, 1796/97

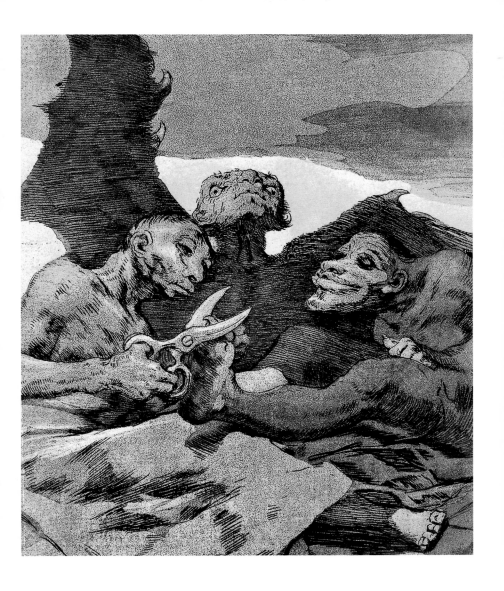

▲ Francisco de Goya *They Spruce Themselves Up. Caprichos No 51*, 1796/97
►► Pieter Bruegel the Elder *Saint Jacob, the Elder with the Magician Hermogenes* (detail).
Engraved by Hieronymous Cock, 1565. Paris, Bibliothèque Nationale

77

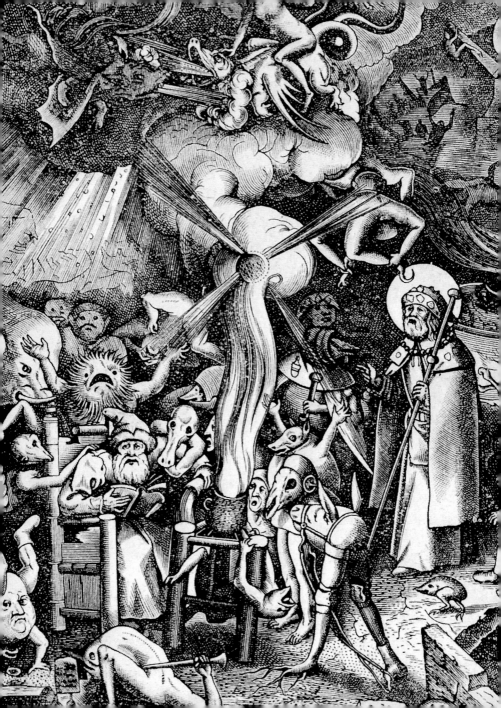

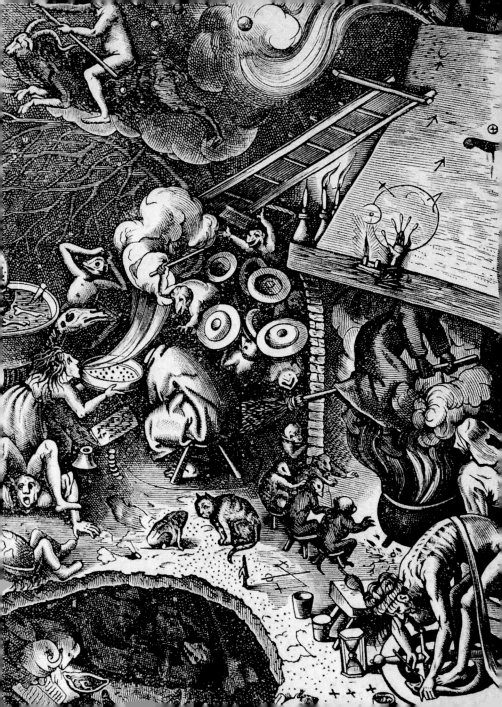

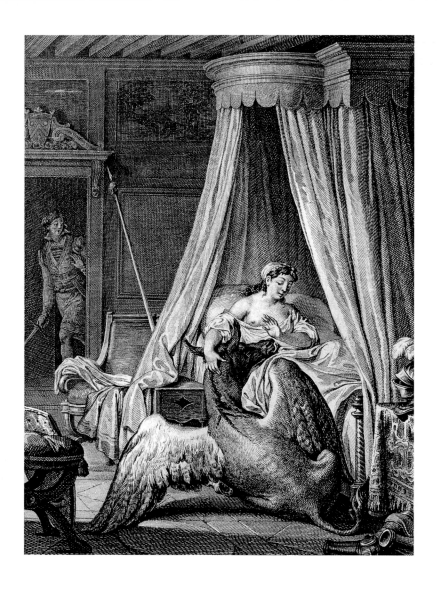

Jean-Michel Moreau the Younger *She Moves Her Hand towards Her Lover.*
Illustration for Voltaire's *La Pucelle d'Orléans*, 18th c.

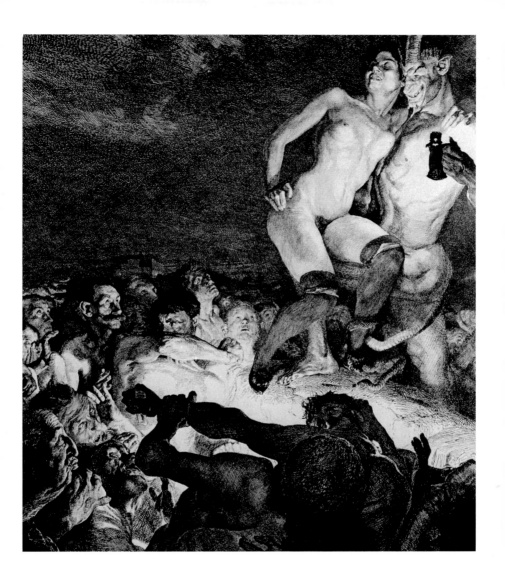

Otto Greiner *The Devil Displaying the Woman to the People.* Lithograph, 1897.
Old argument against women, the devil's instrument.

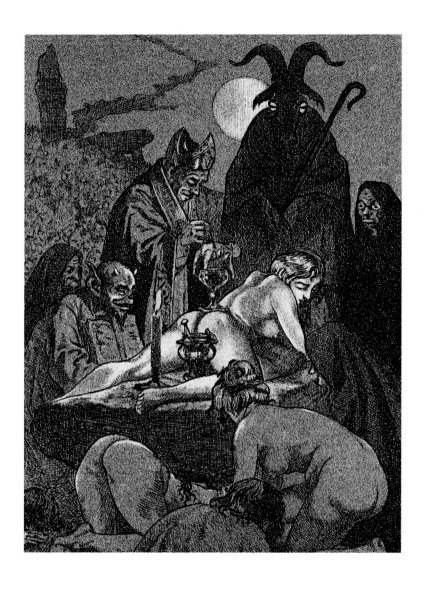

▲▶ **Martin Van Maele** Two illustrations from *La Sorcière* by Jules Michelet. Etching, 1911

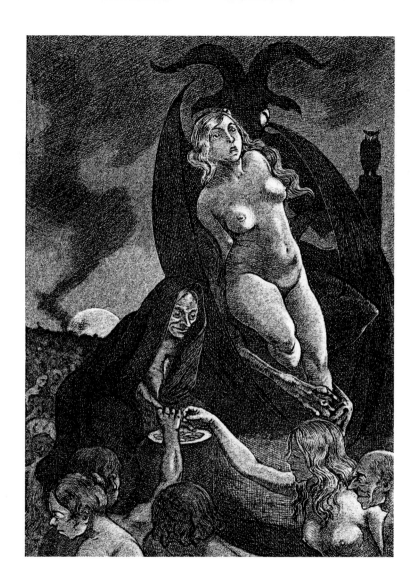

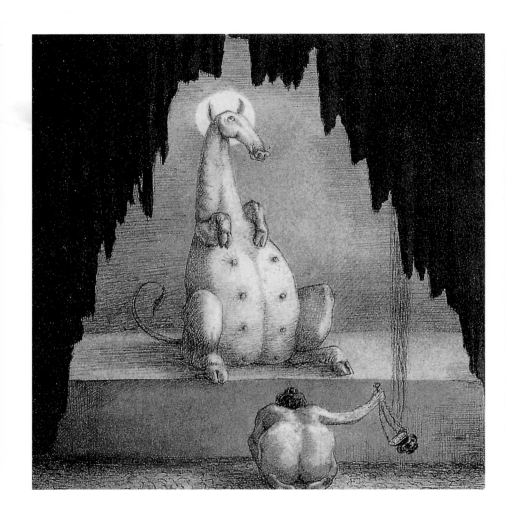

Alfred Kubin *Adoration,* 1901/02

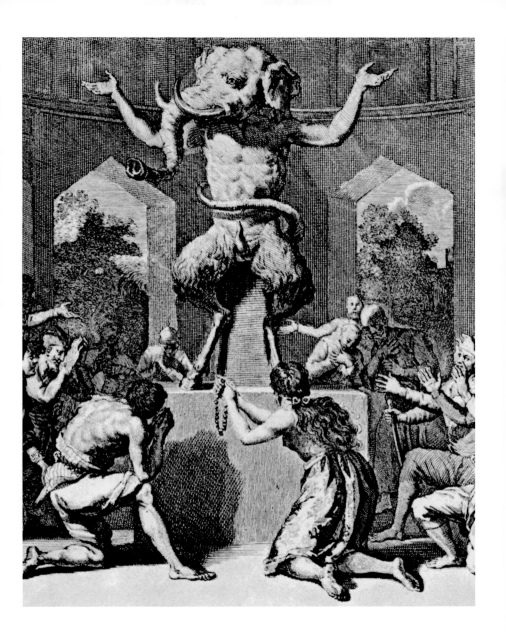

▲ **Bernard Picart** The Singhalese paying tribute to a composite divinity (détail), early 18th c.
►► **Thomas Rowlandson** *Bacchanale anglaise*, c. 1770

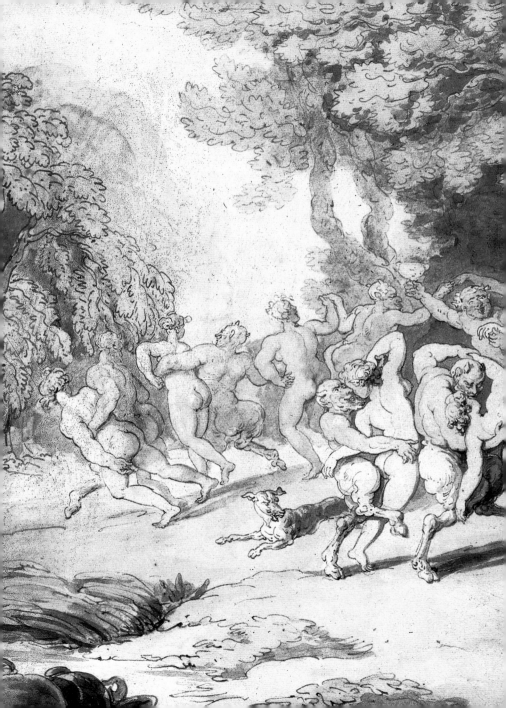

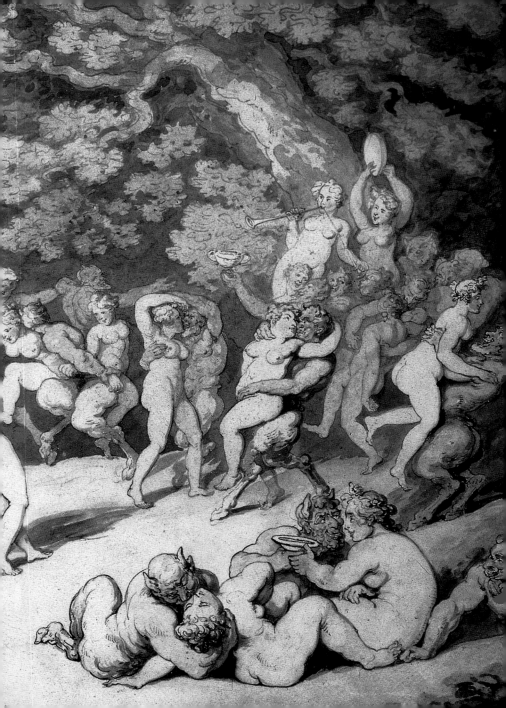

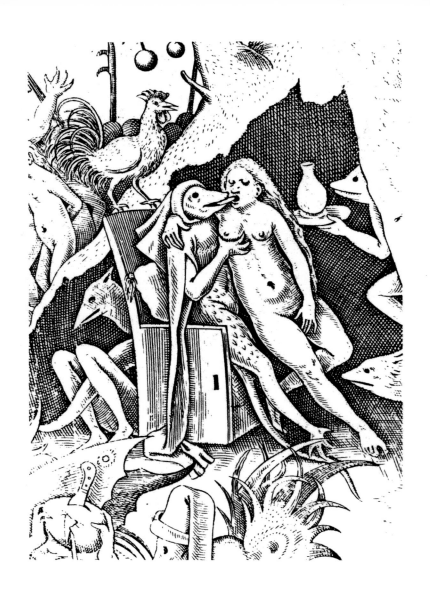

Pieter Bruegel the Elder *Lechery* (detail). Etching, 1558.

Paris, Bibliothèque Nationale

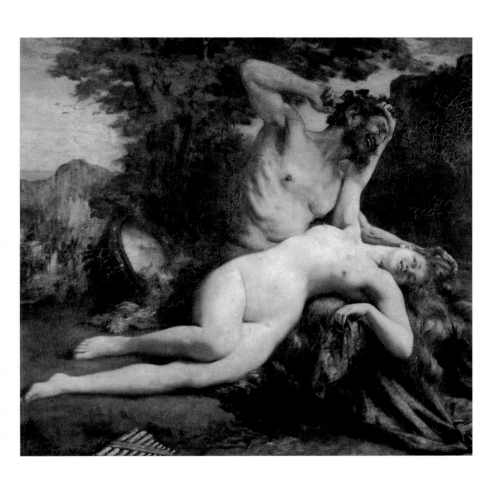

Le Diable «Pompier»:
Henri Gervex *Satyr Playing with a Bacchante*, 1874. Montluçon, Musée de Montluçon.

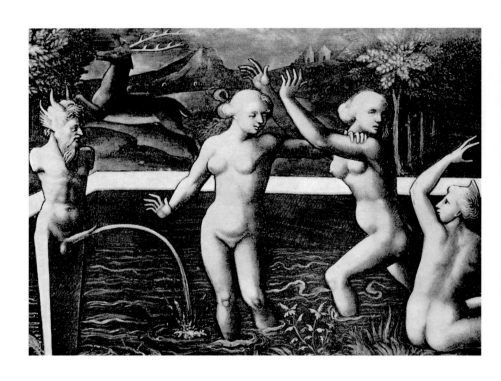

Andrea Mantegna Detail of *Bacchanal*, 15th c. Paris, Musée du Louvre

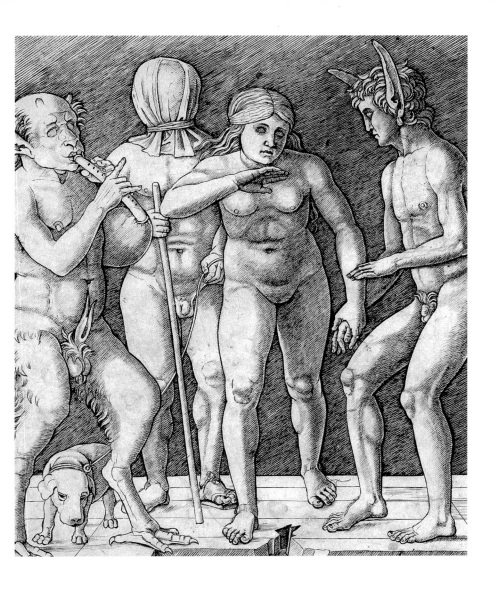

Andrea Mantegna *Initiation* (detail), 15th c. London, British Museum

Ithyphallic Satyr Playing a Flute. Painting on a Greek vase, 5th c. BC.

God Pan. Miniature of the *Echecs amoureux*, late Middle Ages. Paris, Bibliothèque Nationale

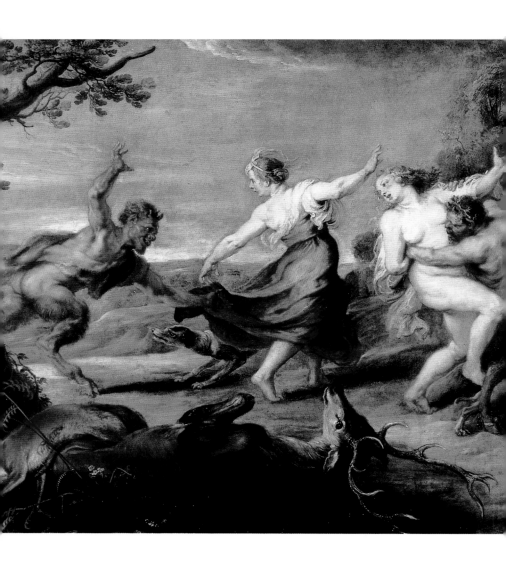

Pieter Paul Rubens *Diana and Her Nymphs Surprised by the Fauns* (detail), 1638–1640.
Madrid, Museo del Prado

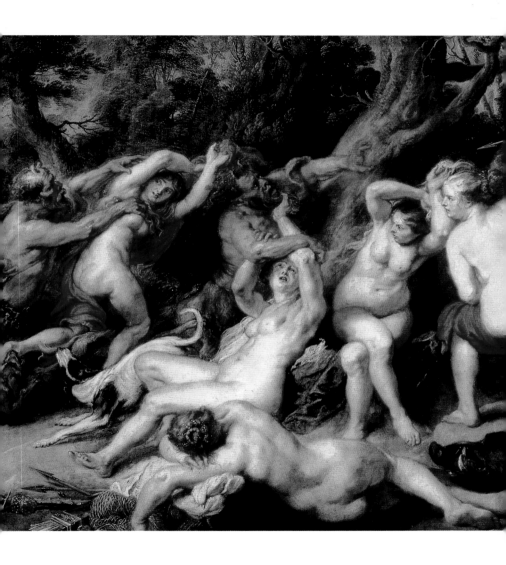

Pan Ogles a Nymph (detail) by a mannerist artist, 16th c.

At the time of the Renaissance, Pan and the Demon were often confused.

Nicolas Poussin *Nymph Syrinx Pursued by Pan* (detail), 1637/38.
Dresden, Staatliche Kunstsammlungen

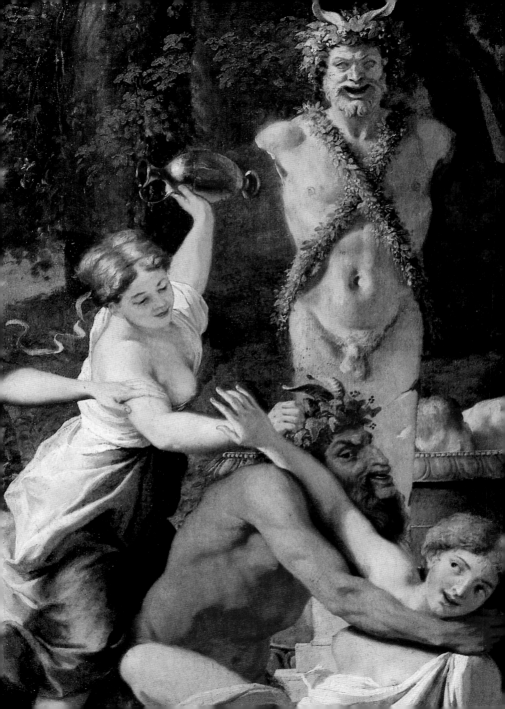

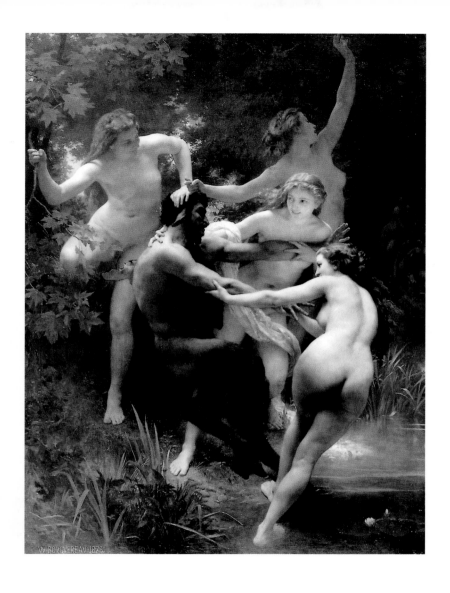

▲ Adolphe-William Bouguereau *Nymphs and Satyr*, 1872.
Williamstown, Sterling and Francine Clark Institute
◄ Nicolas Poussin *A Bacchanalian Revel before a Term of Pan* (detail), c. 1633.
London, National Gallery

▲ A. Galland *Advertisement poster*, c. 1900
▸ Philippe Druillet *Le Gynécée des lionnes*, 1965

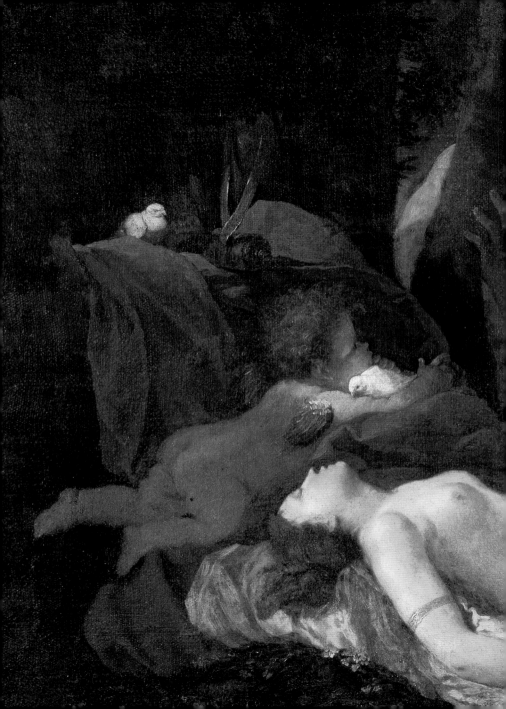

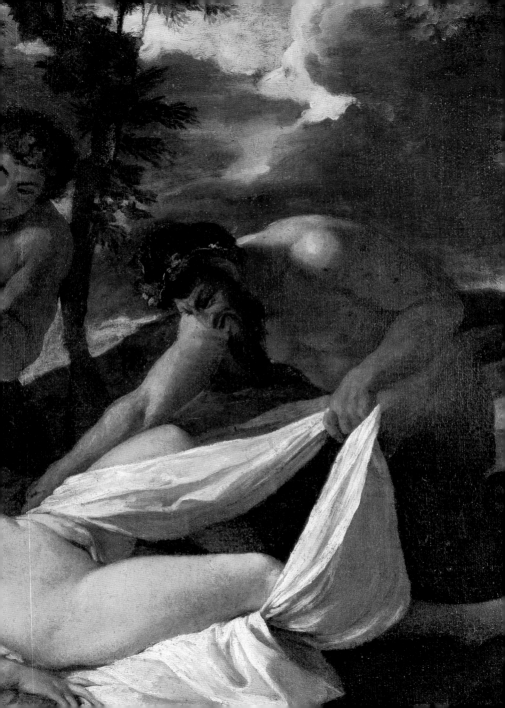

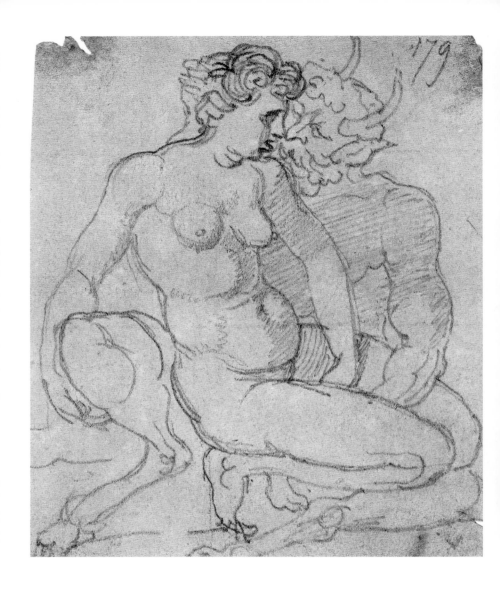

▲ **Jean-Auguste-Dominique Ingres** *Woman and Satyr,* from his sketchbook, 1800–1806
◄◄ **Nicolas Poussin** *Sleeping Venus Surprised by Satyr,* 1626. Zurich, Kunsthaus

Paul Gauguin *L'Esprit veille*. Monotype, 1892

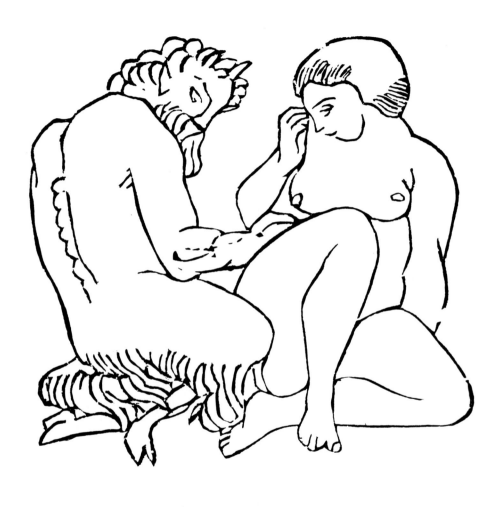

▴ **Aristide Maillol** *The Faun and the Shepardess,* drawing, c. 1920
▸ **Alexandre Cabanet** *Nymph Raptured by a Faun,* 1860. Lille, Musée des Beaux-Arts

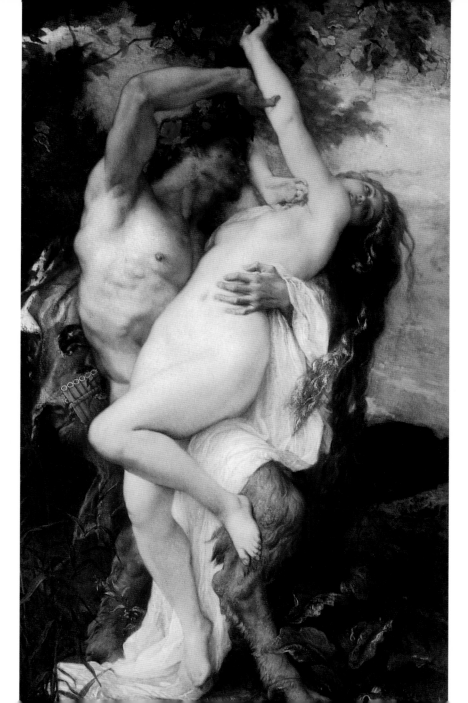

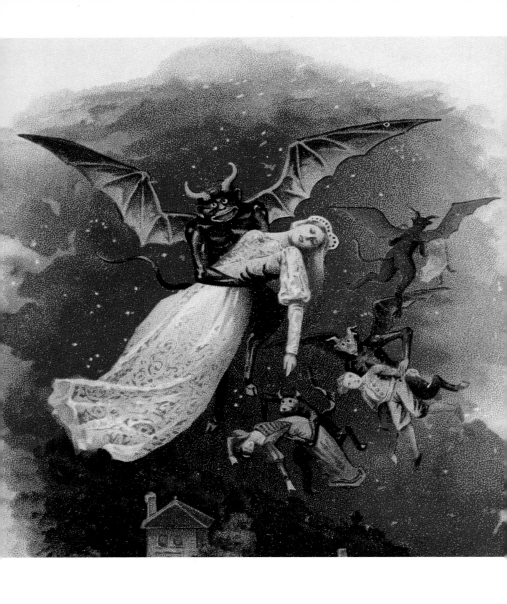

Advertisement for the Parisian department store »Au Bon Marché« (détail), c. 1900.
Paris, Bibliothèque Nationale

The devils get people to buy new clothes, even a young girl to purchase a wedding gown.

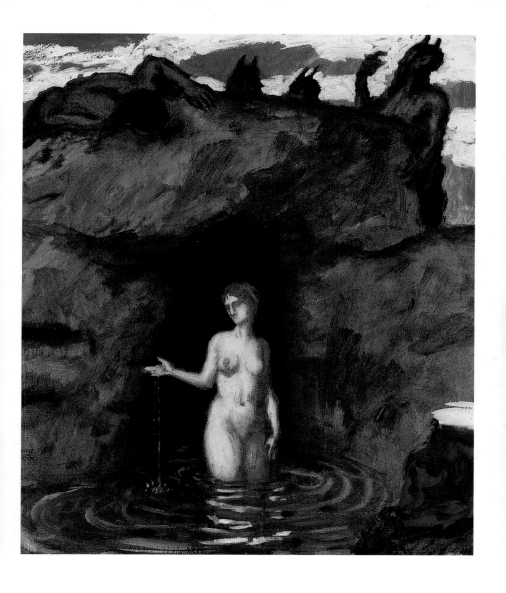

Franz von Stuck *Nymph at a Spring with Fauns*, c. 1911.
Hannover, Niedersächsisches Landesmuseum, Landesgalerie

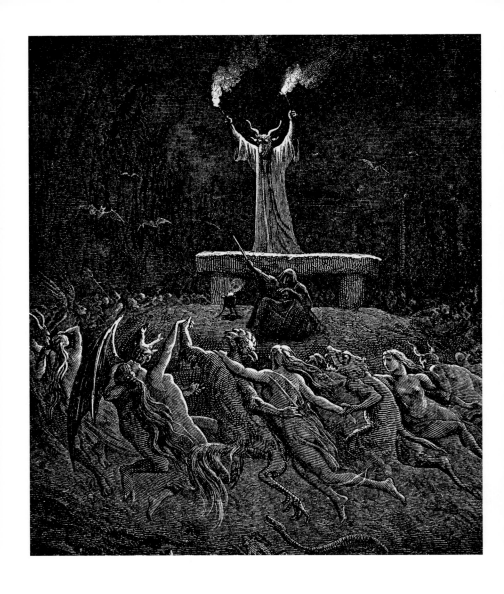

Gustave Doré *La Ronde du Sabbat* (detail).
Engraving for *L'Histoire de la Magie* by Paul Christian, 1870

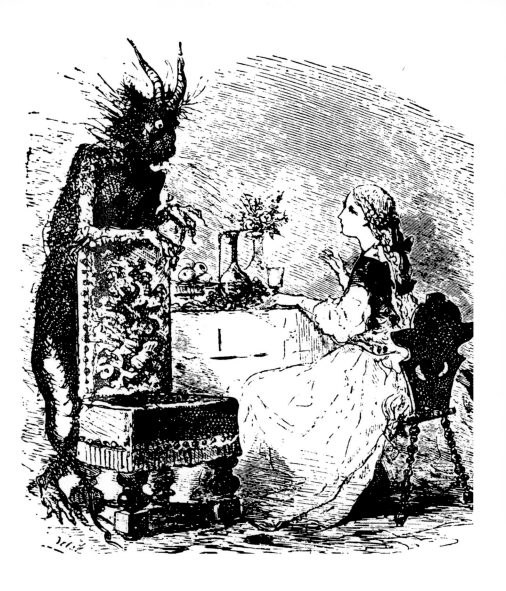

Bertall (**Albert d'Arnoux**) *The Beauty and the Beast* (détail), for an edition of fairy tales, 1860 111

▲ *Woman and a Devil Puppet.* Hungarian postcard, 1915

▶ *Who is More Lucky: The Devil or the Husband?* English postcard, 1915

▶▶ *Image d'Epinal. The Truth of the Day or the Evil of Money.*
Coloured engraving, c. 1840. Paris, Bibliotheque Nationale
The great silver devil spreads his gold on crooks, prostitutes, thieves, lawyers, speculators … 113

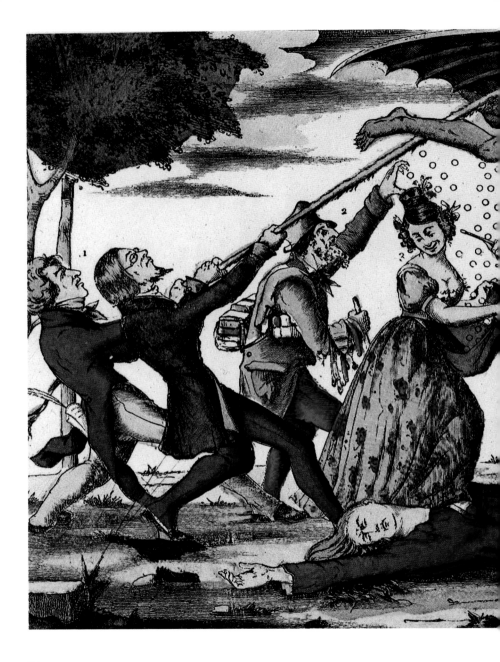

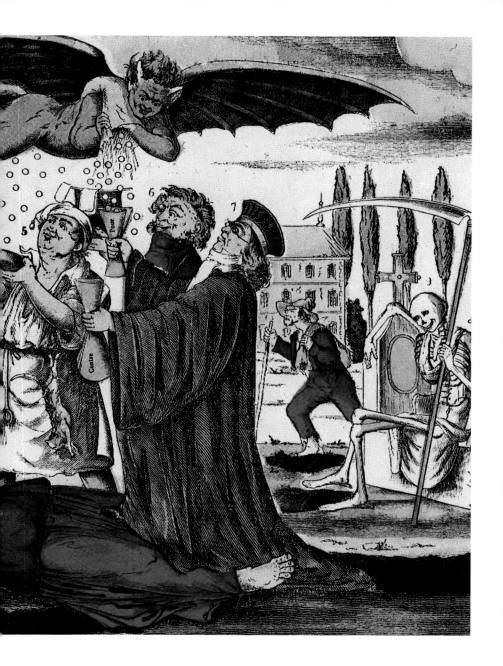

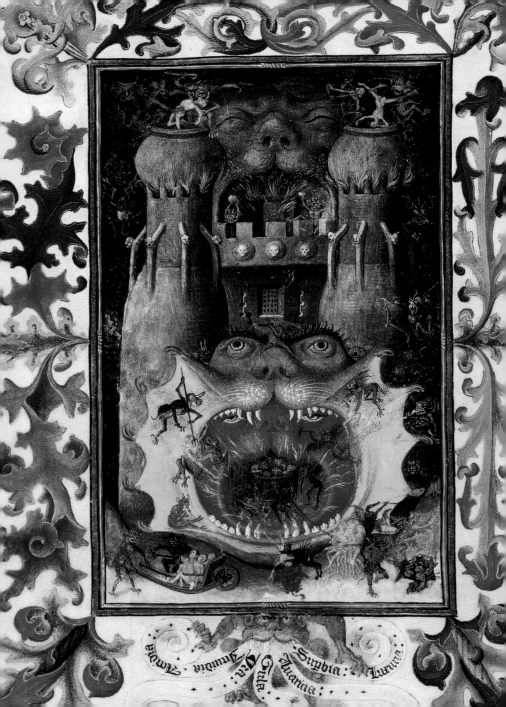

Srypbia · Luxuria · Avaricia · Gula · Yra · Invidia · Almdia

In the Mouth of Hell

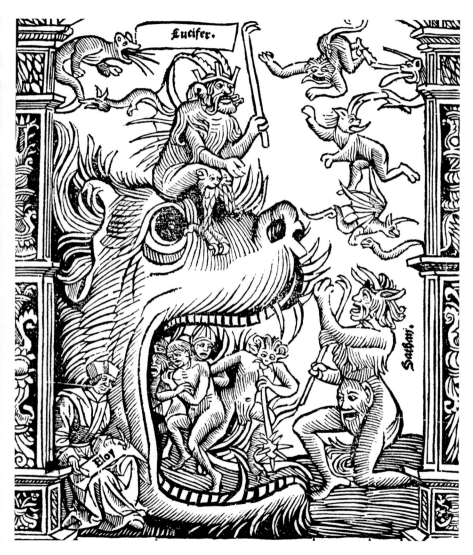

▲ *The Mouth of Hell.* Engraving, at the end of the Middle Ages
◄ *The Mouth of Hell.* Miniature from the *Book of Hours of Catherine of Cleves*, c. 1440.
New York, The Pierpont Morgan Library

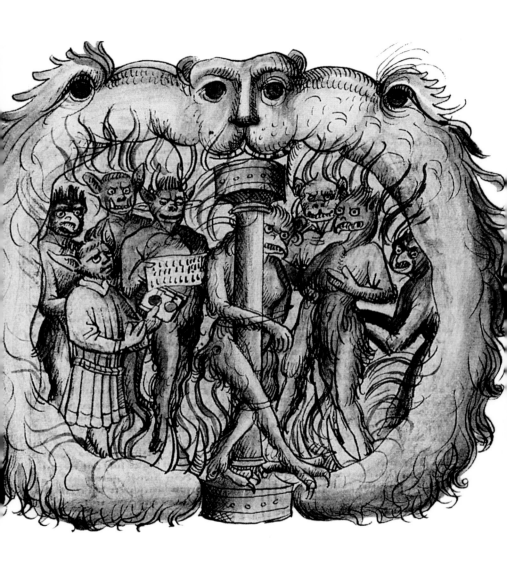

▲ *The Mouth of Hell*. Illustration from a German manuscript, 15th c.
▶ *Diablerie*. Miniature from a French manuscript, late 15th c.

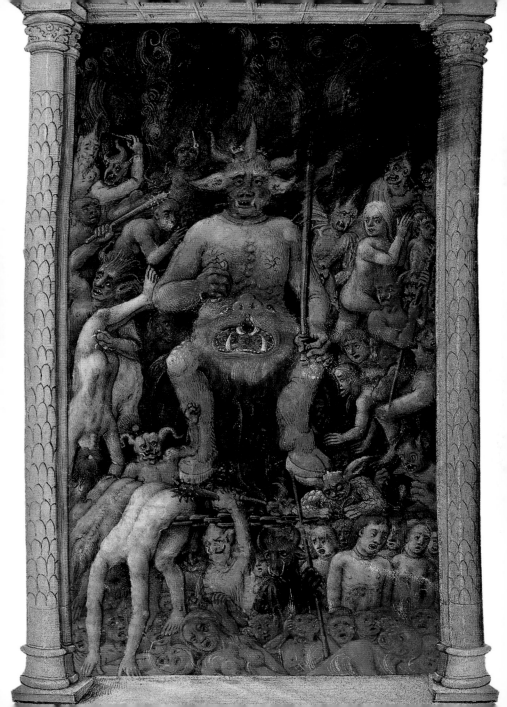

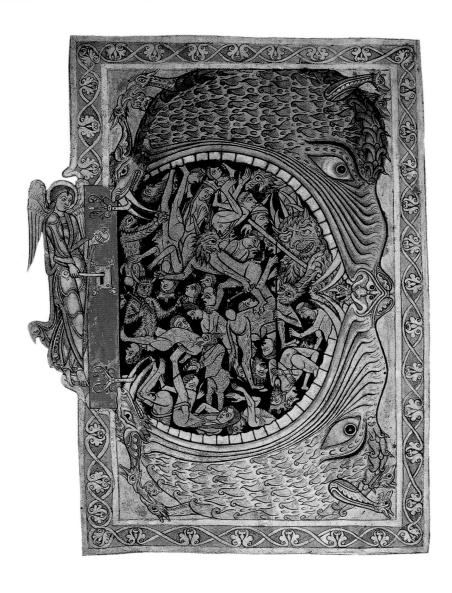

Hell, Frightening Mouth that Bites. Miniature from the *Winchester Psalter*, c. 1161.
London, British Library

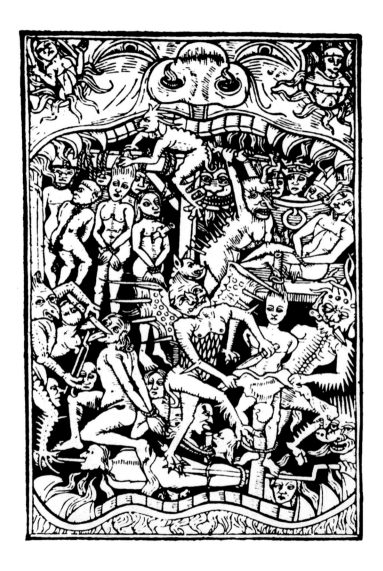

▲ *Hell.* Illustration from a Spanish *Libro del Antichristo*, 14th c.
►► *The Apocalyptic Beast*, the Cerberus of medieval times, watches at the leviathan mouth, to stop the Damned from trying to escape. Manuscript of an *Apocalypse*, illuminated in Northern France, 13th c. Cambrai, Bibliothèque de Cambrai

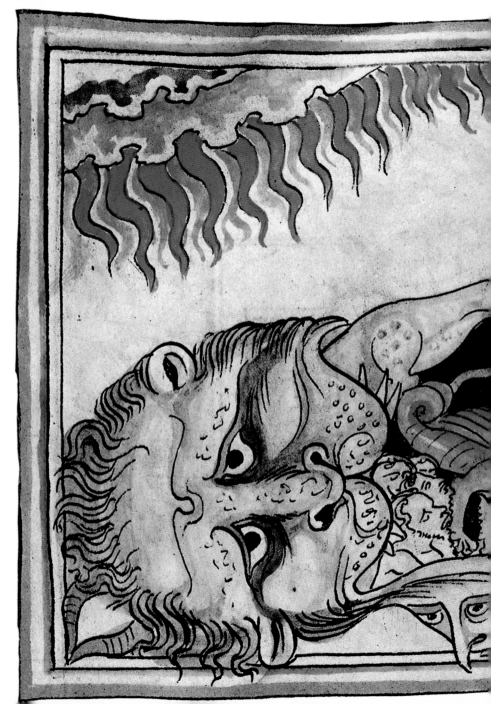

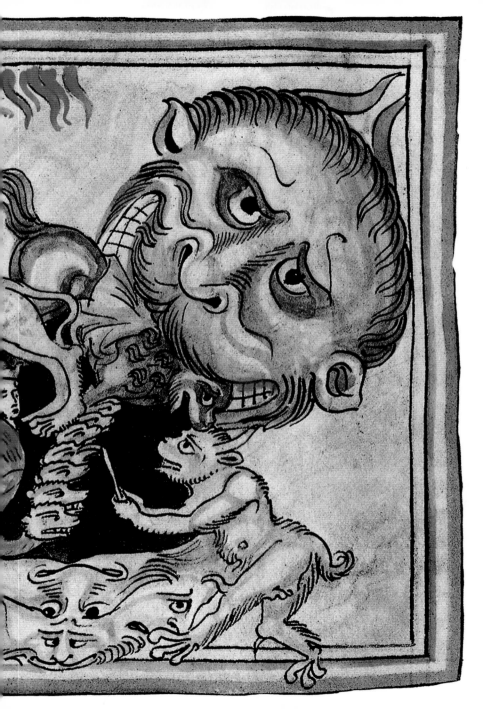

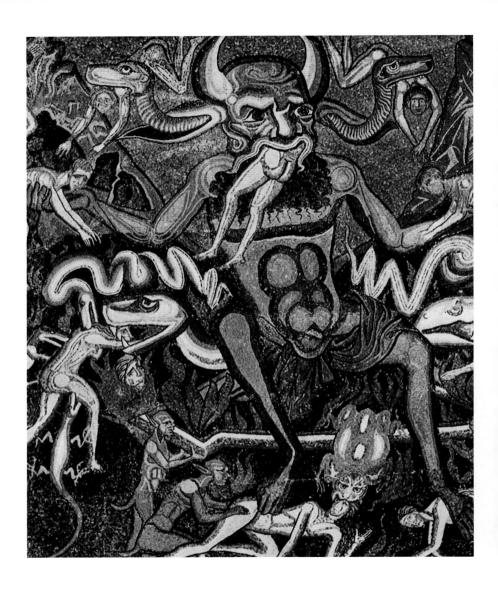

Lucifer Devouring the Damned. Detail of the cupola mosaic, attributed to Coppo di Marcovaldo, 13th c. Florence, Battistero San Giovanni

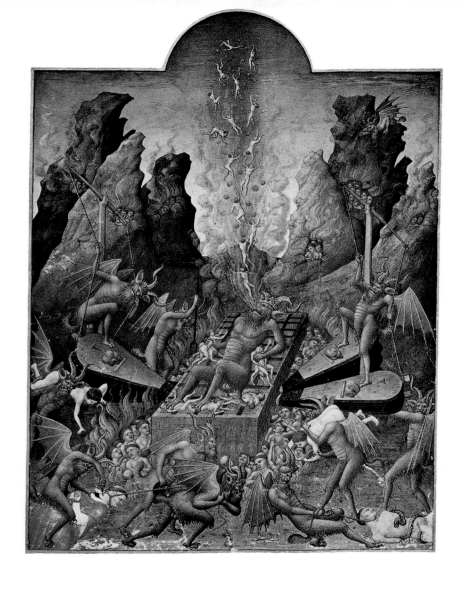

The Limburg Brothers *Hell: Leviathan with Burning Breath.* Miniature from the
Très Riches Heures du Duc de Berry, c. 1410–1416. Chantilly, Musée Condé

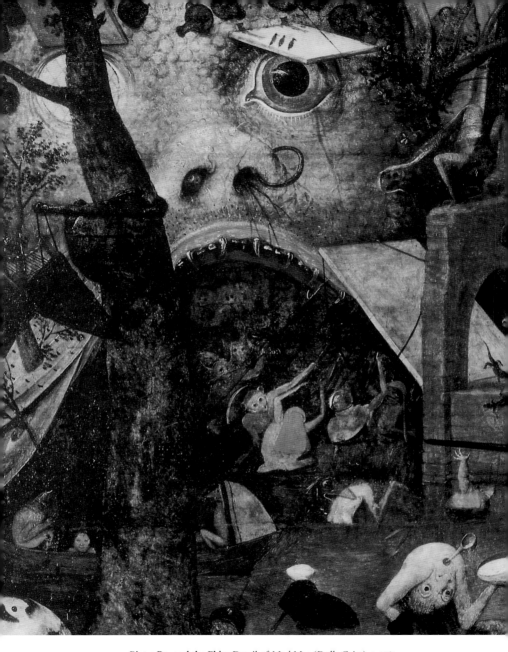

Pieter Bruegel the Elder Detail of *Mad Meg (Dulle Griet)*, c. 1562.
Antwerp, Museum Mayer van den Bergh

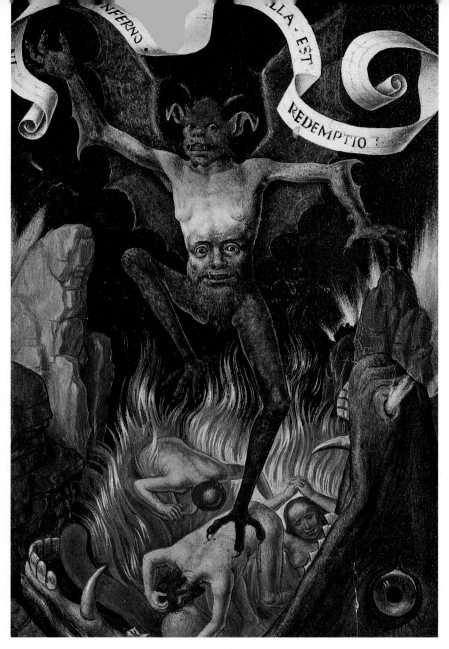

Hans Memling (workshop) *The Mouth of Leviathan.* Panel of the *Polyptych of Vanity*, c. 1485. Strasbourg, Musée des Beaux-Arts

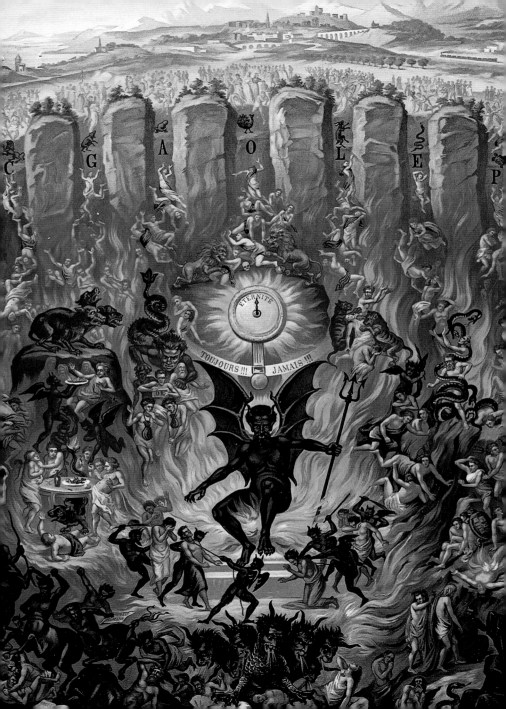

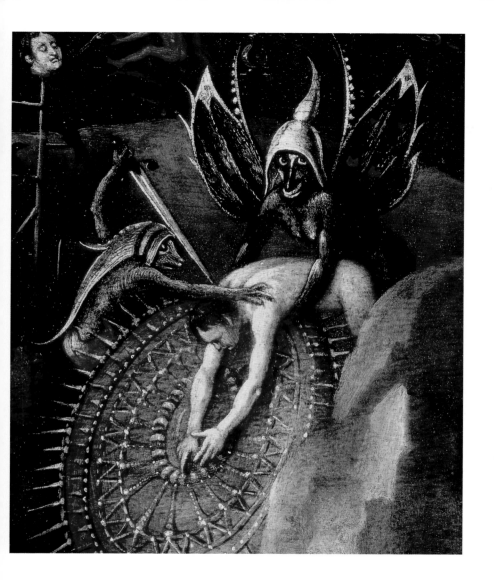

▲ **Henri Met de Bles** Detail of *Hell*, 1550. Venice, Palazzo Ducale
◄ **French anonymous** *The Punishment of the Damned*, 19 c.
C for Colère (anger), G for Gourmandise (gluttony), A for Avarice (avarice),
O for Orgueil (pride), L for Luxure (lechery), E for Envie (envy), P for Paresse (indolence). 129

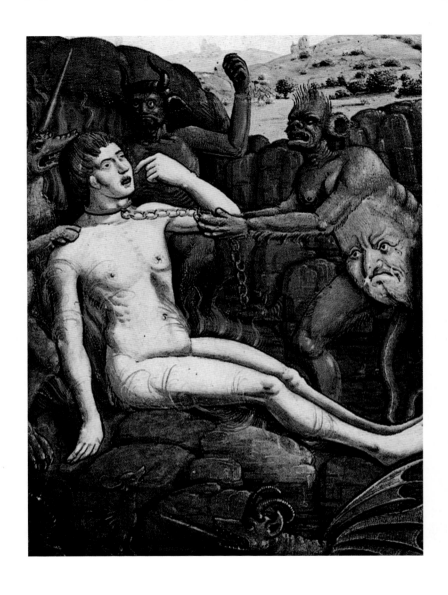

The Torments of the Damned. French miniature (detail) from the *Book of Hours of Henry IV*, c. 1500. Paris, Bibliothèque Nationale

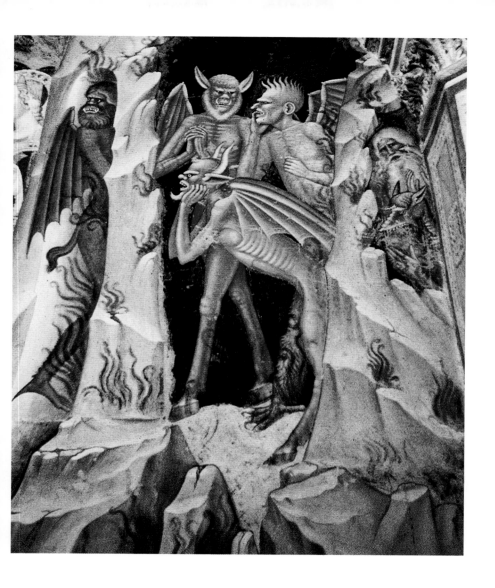

Andrea da Firenze *The Descent into Limbo.* (detail). Fresco, 1365.
Florence, Santa Maria Novella, Cappellone degli Spagnoli

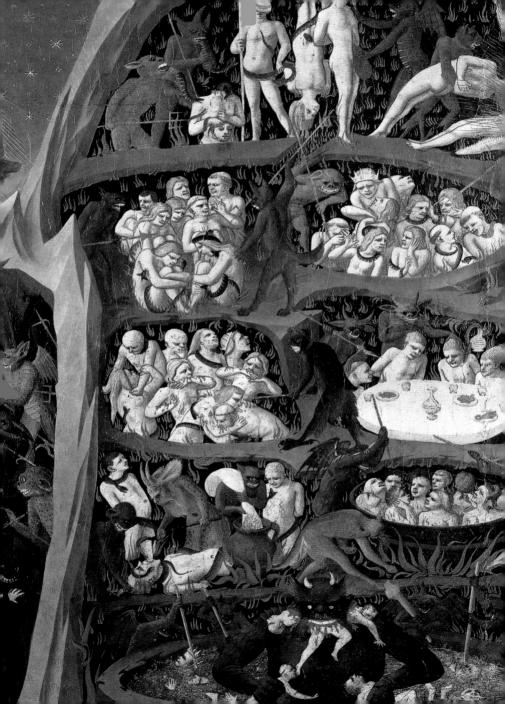

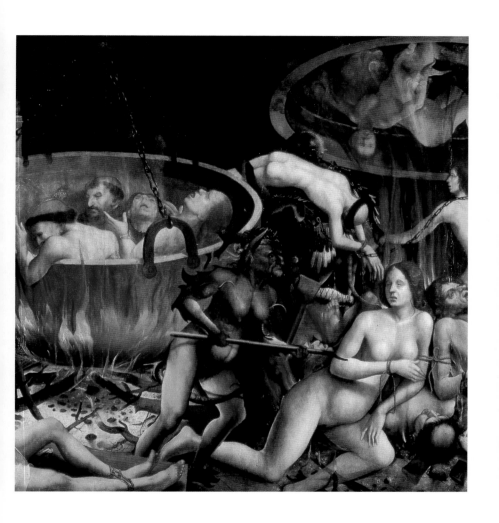

▲ *Hell* (detail) by an unknown Portuguese artist, 16th c.
Lisbon, Museu Nacional de Arte Antiga
◄ **Fra Angelico** *The Damned.* Detail of *The Last Judgement*, 1432–1435.
Florence, Museo di San Marco

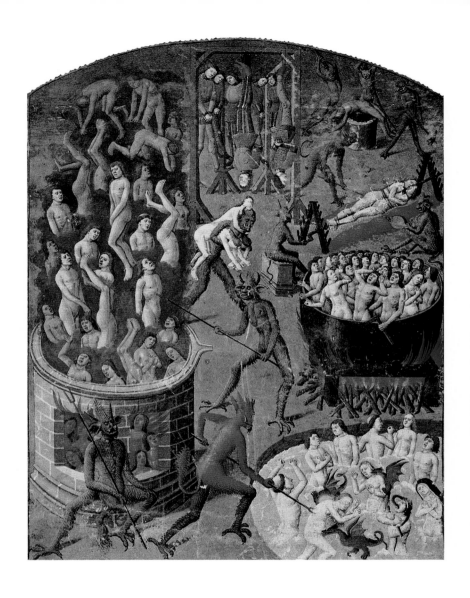

The Infernal Torments of the Damned. Miniature from an illuminated French manuscript
of Augustine's *City of God*, 15th c. Paris, Bibliothèque Sainte-Geneviève

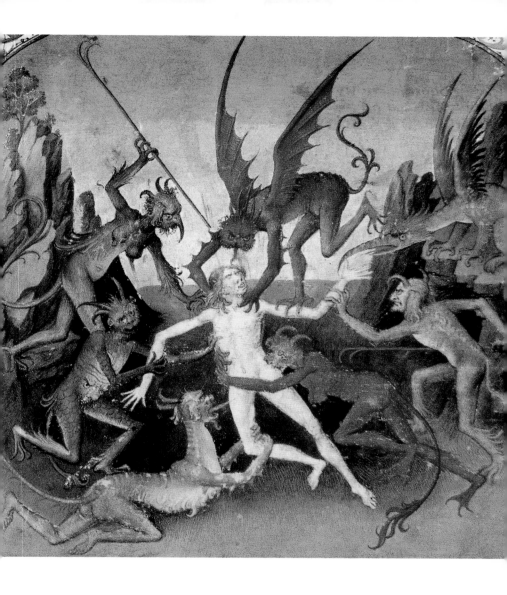

▲ *The Book of the Seven Mortal Sins.* Miniature from an illuminated French manuscript,
15th c. Paris, Bibliothèque Nationale
▶▶ **Giotto di Bondone** *The Last Judgement.* Detail of the fresco covering the entrance wall,
1302–1305. Padua, Cappella degli Scrovegni (Arena Chapel) 135

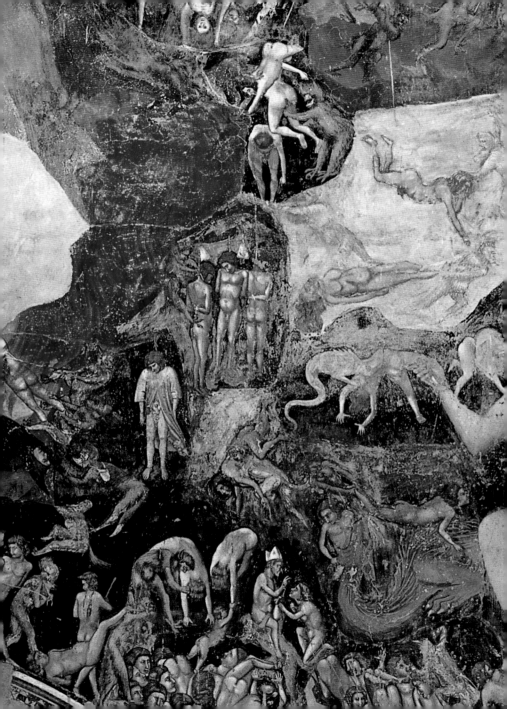

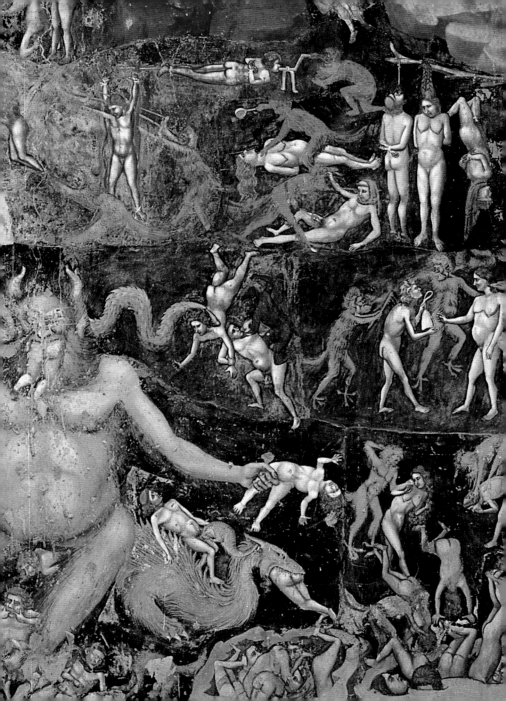

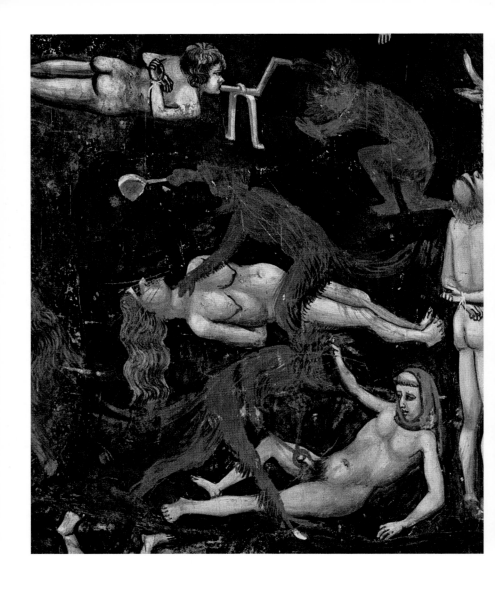

▲► **Giotto di Bondone** *Demons and Their Tortures.* Two details of *The Last Judgement.*
Fresco, 1302–1305. Padua, Cappella degli Scrovegni (Arena Chapel)

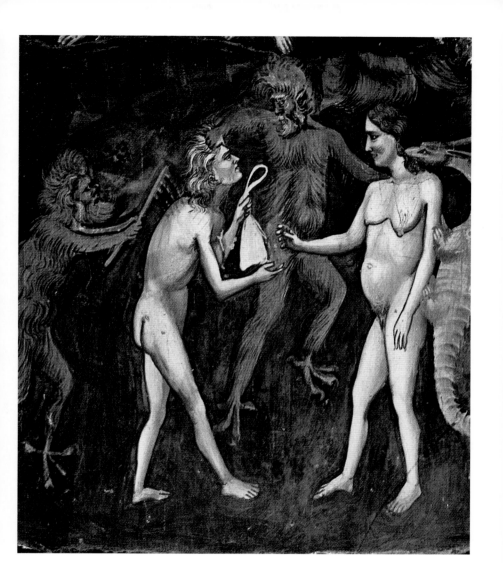

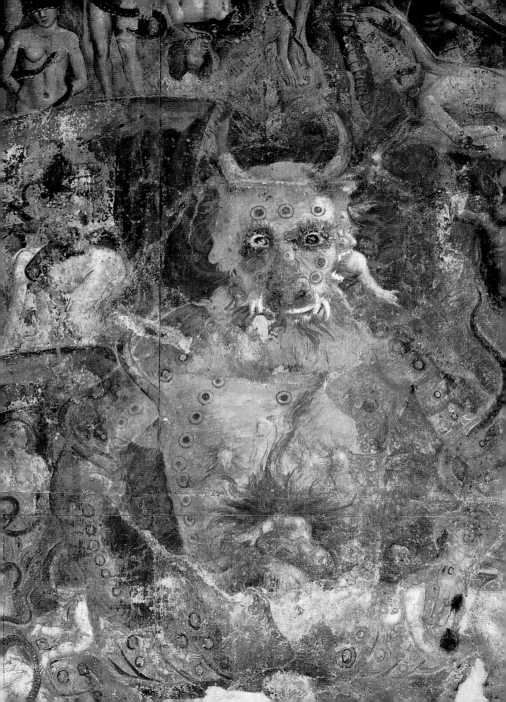

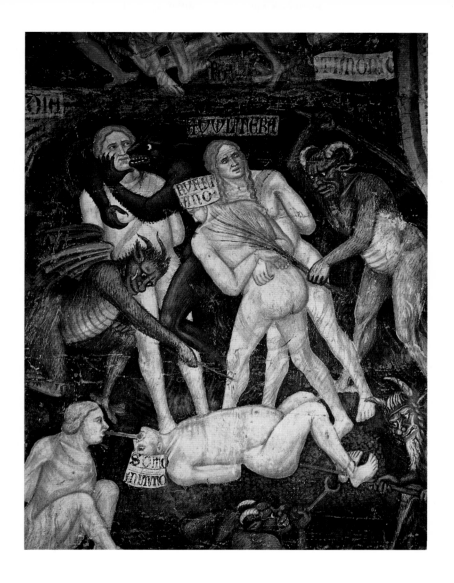

▲ Taddeo di Bartolo *Hell: Lechery.* Detail of *The Last Judgement.* Fresco, c. 1393–1413.
San Gimignano, Collegiata Santa Maria Assunta
◄ Francesco Traini *The Bestial Satan of Grotesque Beauty.* Detail of *The Triumph of Death.*
Fresco, c. 1325–1350. Pisa, Camposanto

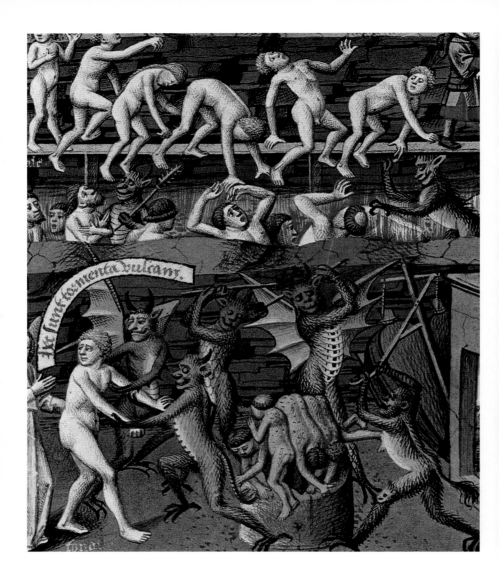

▲ *The Torments of Hell.* Miniature (detail) from an illuminated *Historical Mirror* by
Vincent de Beauvais, late 15th c. Chantilly, Musée Condé
▶ **Giorgio Vasari** and **Federico Zuccari** *Punishment of Lechery.* Detail of the cupola fresco,
1572–1579. Florence, Duomo Santa Maria del Fiore

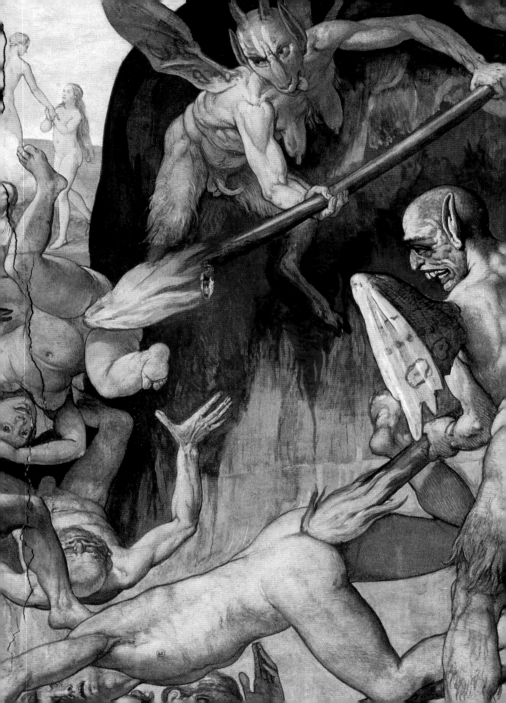

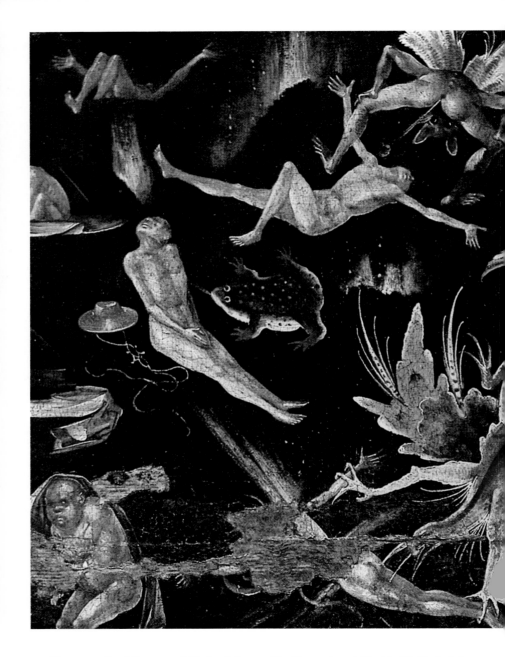

144 **Hieronymus Bosch** Fragment of *The Last Judgement* (detail), c. 1506–1508. Munich, Alte Pinakothek

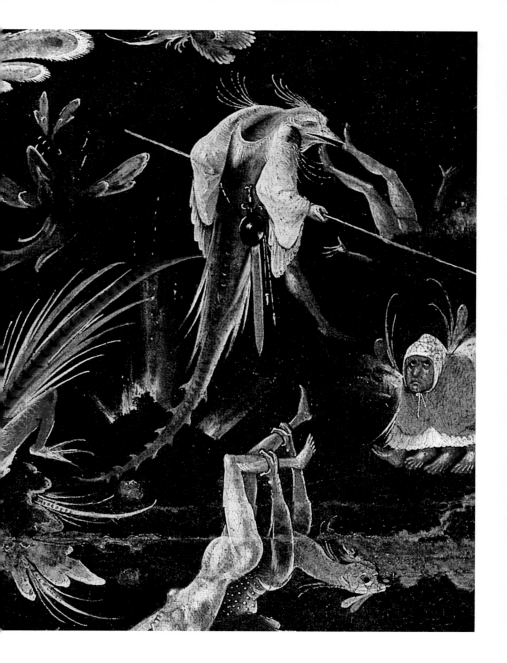

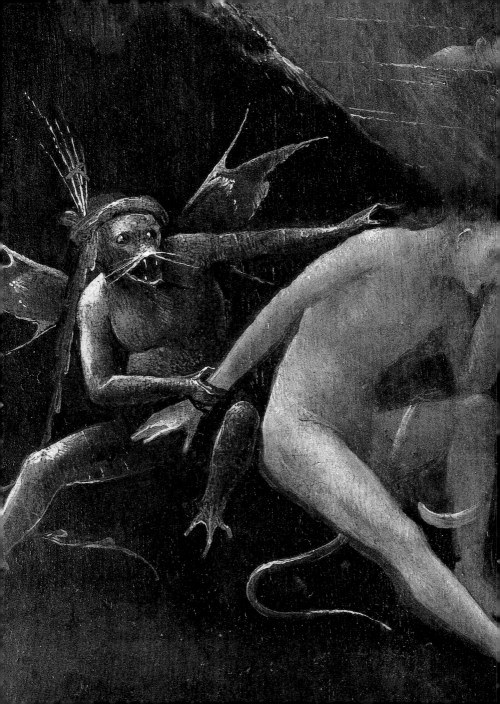

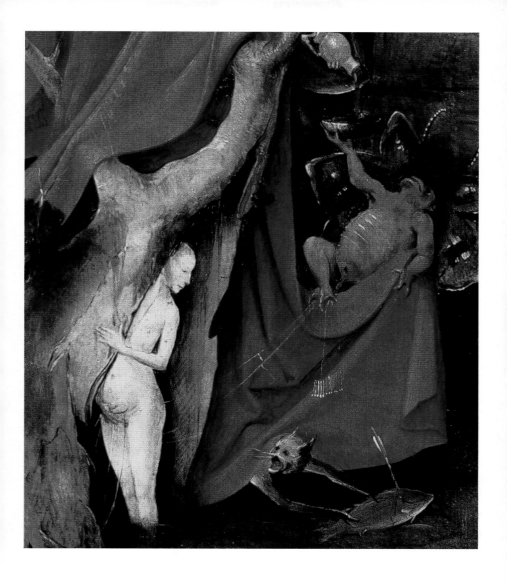

▴ **Hieronymus Bosch** *The Temptation of Saint Anthony* (detail), c. 1500–1509.
Antiga, Museu Nacional de Arte
◂ **Hieronymus Bosch** *Four Visions of the Hereafter.* Detail of *Hell*, c. 1490.
Venice, Palazzo Ducale

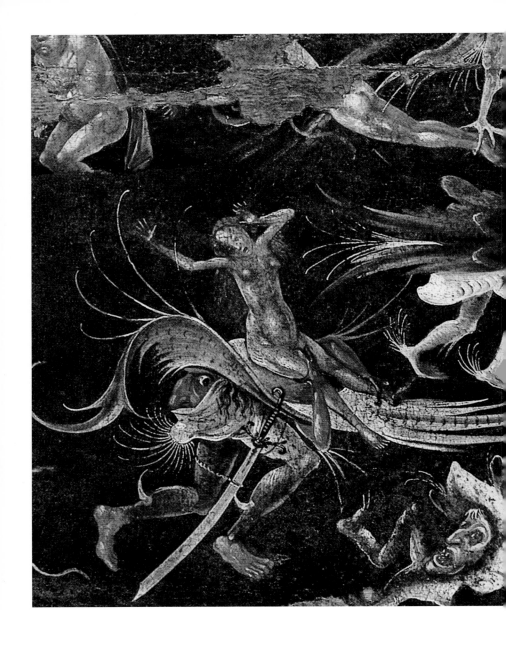

Hieronymus Bosch Fragment of a *Last Judgement* (detail), c. 1506–1508.
Munich, Alte Pinakothek

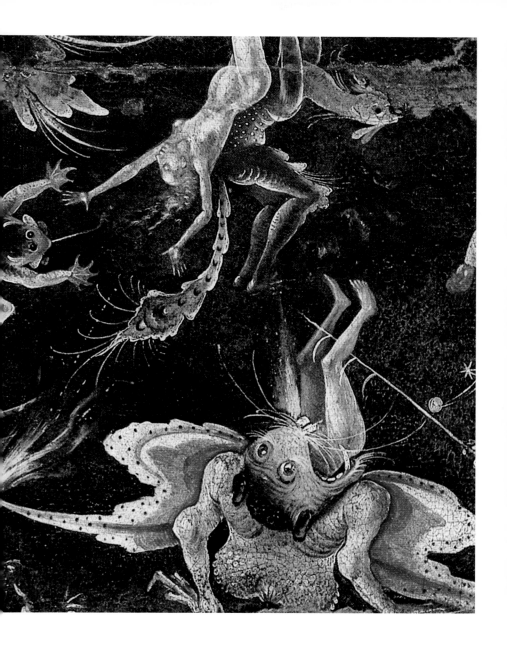

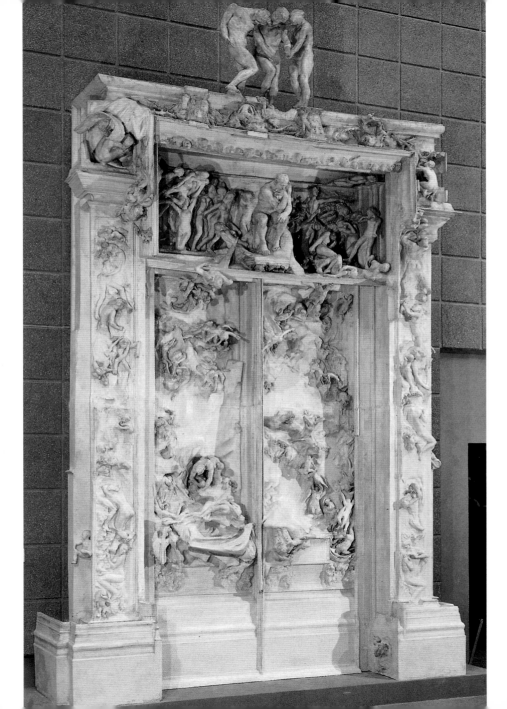

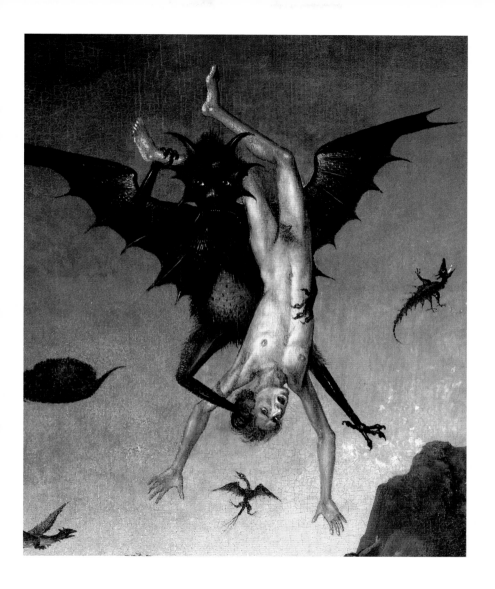

▲ **Dieric Bouts** *The Fall of the Damned*. Detail of *Hell*, c. 1450. Lille, Musée des Beaux-Arts
◄ **Auguste Rodin** *The Gates of Hell*, 1880–1917. Paris, Musée d'Orsay 151

▲ After **Luca Signorelli** *Punishment of a Damned Soul.*
Drawing after *The Last Judgement* in Orvieto, 1499–1504
▶ **Michelangelo** *The Last Judgement* (detail), 1537–1541.
Rome, Palazzi Vaticani, Cappella Sistina

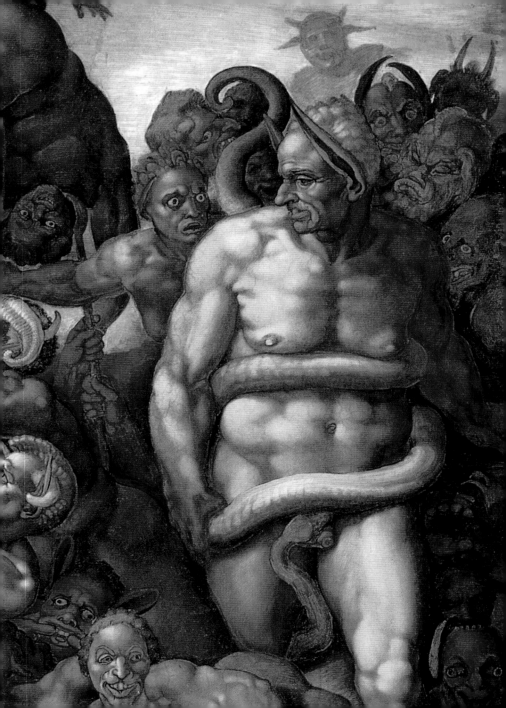

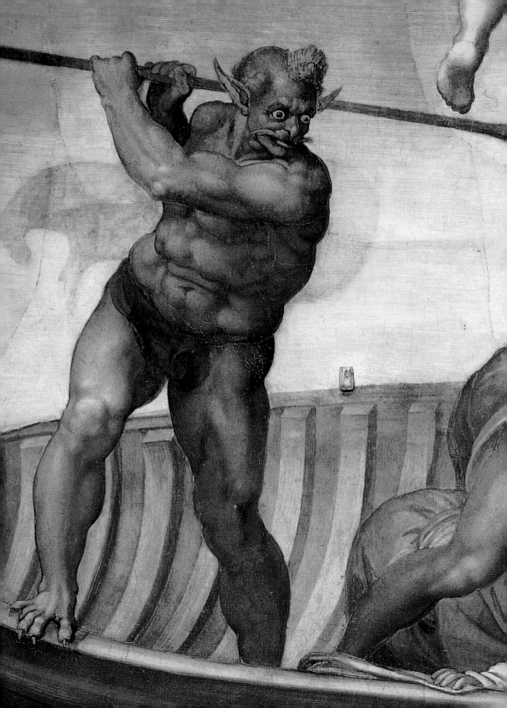

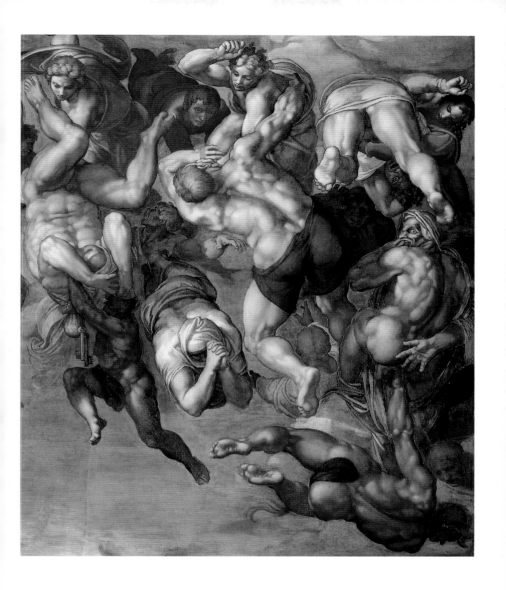

▲ **Michelangelo** *Punishment of Sodomy.* Detail of *The Last Judgement*, 1537–1541.
Rome, Palazzi Vaticani, Cappella Sistina
◄ **Michelangelo** *The Damned: Charon the Bargeman.* Detail of *The Last Judgement*, 1537–1541.
Rome, Palazzi Vaticani, Cappella Sistina 155

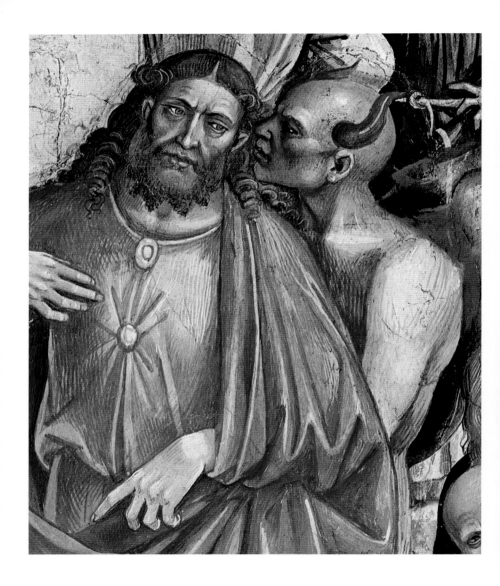

▲ **Luca Signorelli** Detail of *The Deeds of the Antichrist.* Fresco, 1499–1504. Orvieto, Duomo.
The demon whispers into the ear of the Antichrist the words asking for chaos.
▸ **Michael Pacher** *The Devil Shows the Book of Sins to Saint Augustine.*
Detail of the *Altarpiece of the Church Fathers*, 1483. Munich, Alte Pinakothek
▸▸ **Luca Signorelli** Detail of *Hell.* Fresco, 1499–1504. Orvieto, Duomo

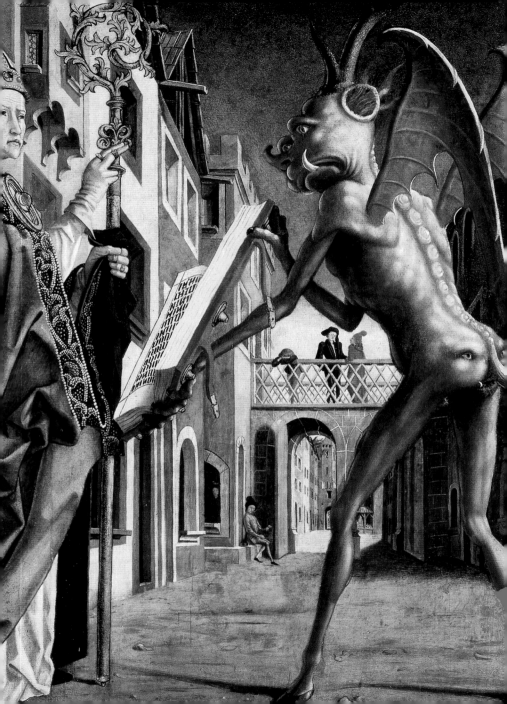

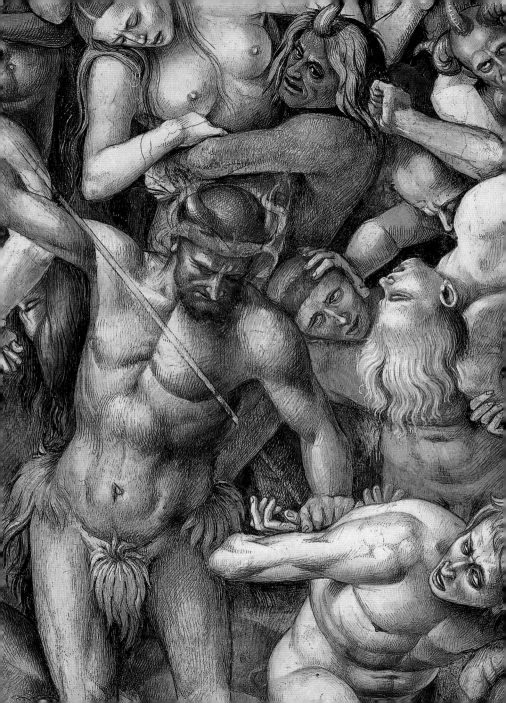

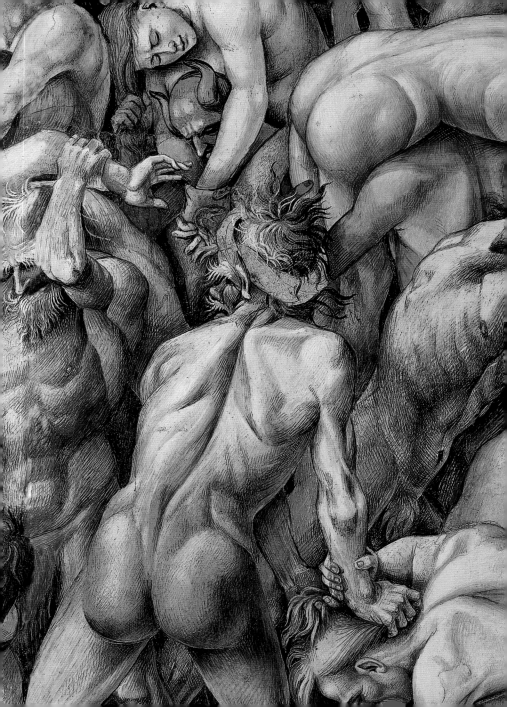

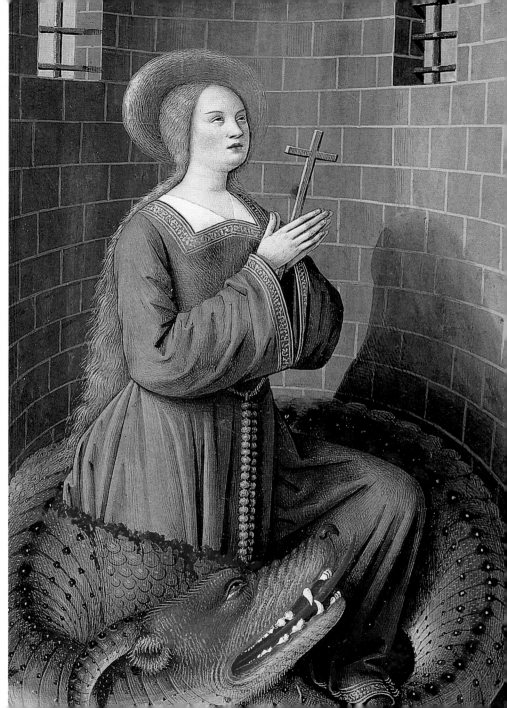

The Triumph of Good over Evil

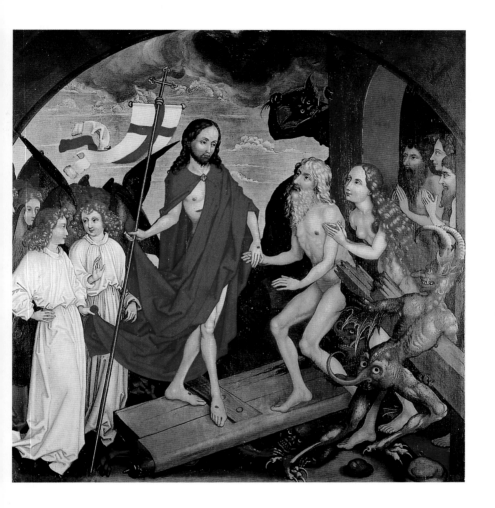

▲ **Martin Schongauer (workshop)** *The Descent of Christ into Limbo*. Panel from the
Altarpiece of the Dominican Church, 1475. Colmar, Musée d'Unterlinden
◄ **Jean Bourdichon** *Saint Margaret with the Dragon*. Miniature (detail) from the
Grandes Heures d'Anne de Bretagne, c. 1503–1508. Paris, Bibliothèque Nationale

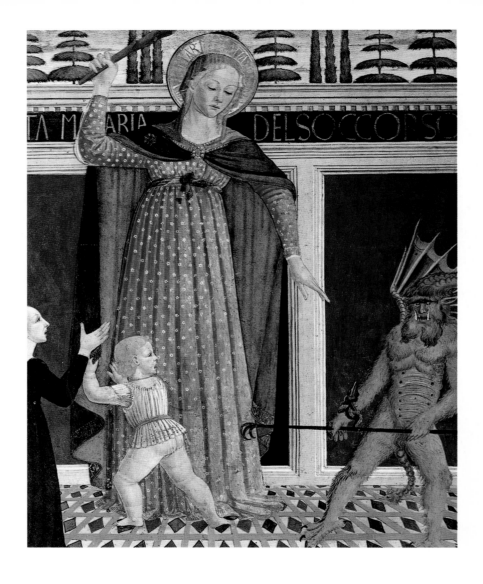

The Virgin and the Demon.
Detail of the fresco by an unknown Florentine artist, 15th c. Florence, Church Santo Spirito
The Virgin of Mercy protects a child from the claws of the demon.

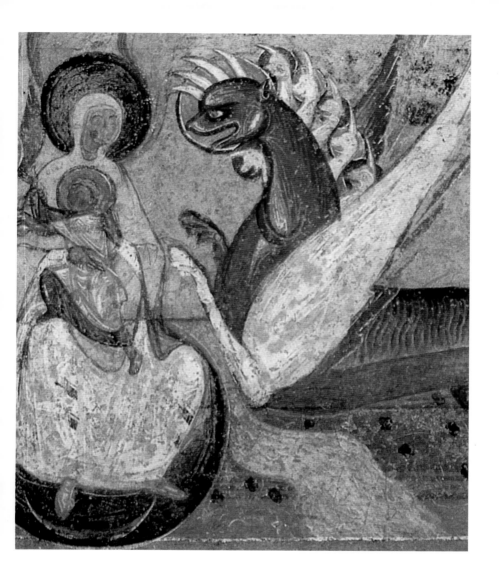

The Sun-Woman Facing the Dragon. Detail of a Romanesque fresco, 12th c.
Saint-Savin-sur-Gartempe, Abbatiale

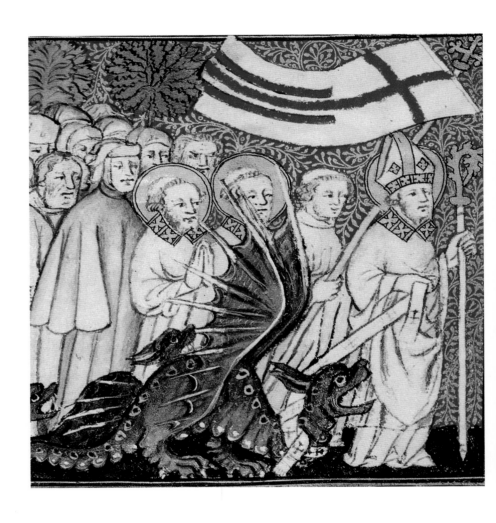

Saint Clément and Graoully de Metz. Miniature from an illuminated French manuscript of *The Life of Saint Clement*, 16th c. Paris, Bibliothèque de l'Arsenal

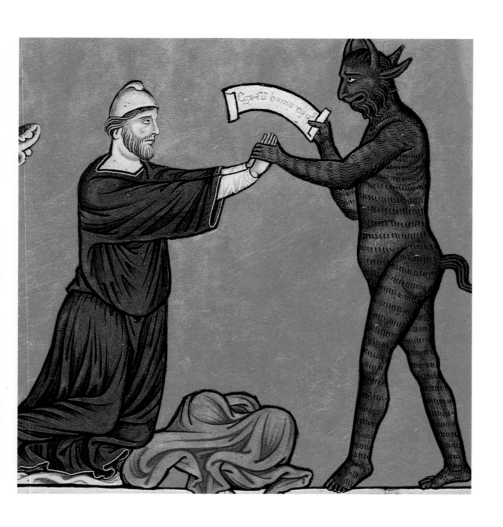

The Miracle of Theophile, who, having signed a pact with the Devil,
repented and was pardoned by the Virgin Mary. Miniature (detail) from the *Ingeborg Psalter*,
made for the wife of the King of France, c. 1195. Chantilly, Musée Condé

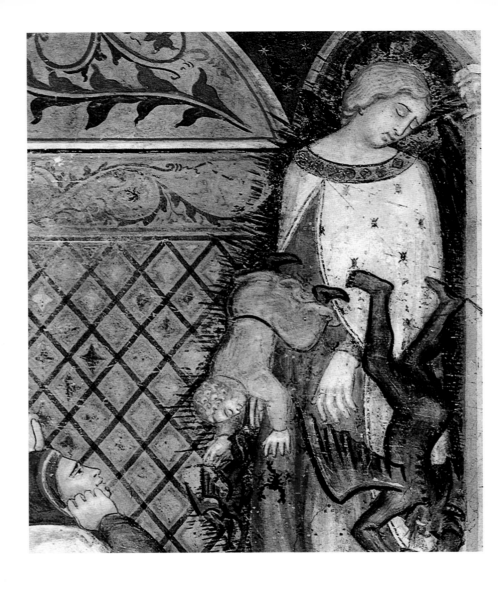

Ugolino di Prete Ilario *The Demons Expelled from the Body of a Possessed Woman.*
Detail of the fresco in the Chapel of the Corporale, 1364. Orvieto, Duomo

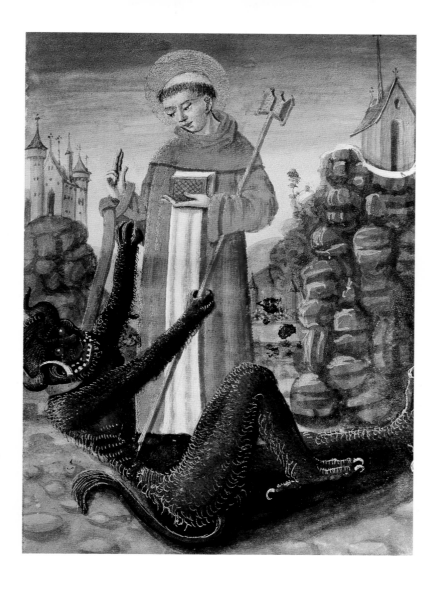

Saint Bernard Overcoming a Demon. Miniature from a French Book of Hours, 1490.
Paris, Bibliothèque de l'Arsenal

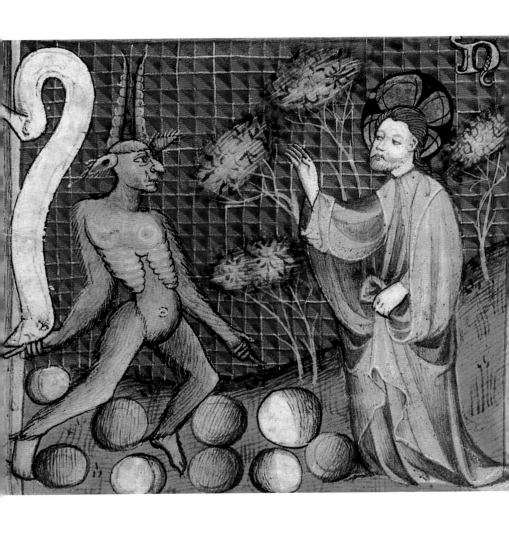

The Temptation of Christ in the Desert. Miniature from an illuminated German
Life of Christ, 15th c. Chantilly, Musée Condé

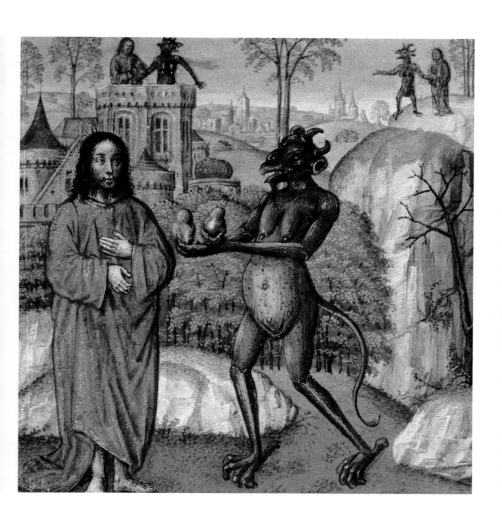

The Temptation of Christ. Miniature (detail) from an illuminated Flemish
Mirror of Salvation, 15th c. Chantilly, Musée Condé

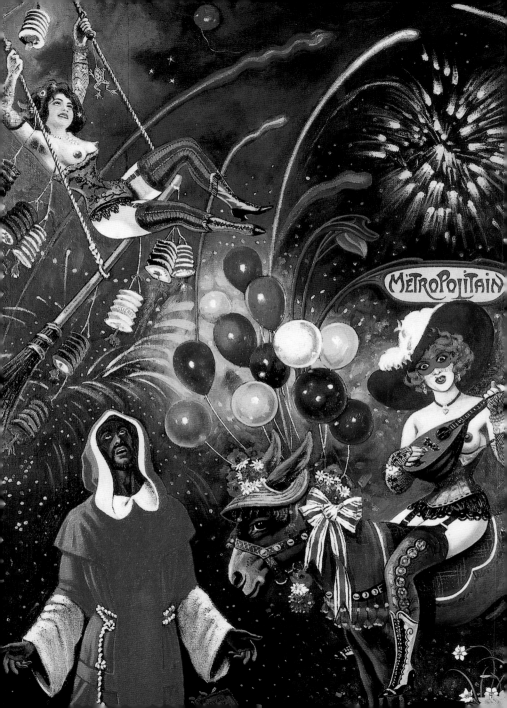

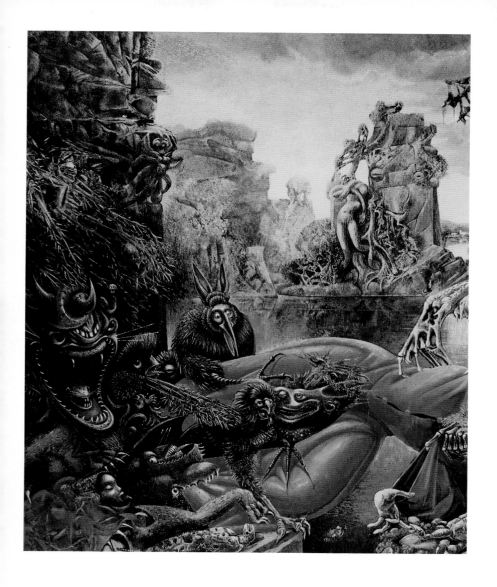

▲ Max Ernst *The Temptations of Saint Anthony* (detail), 1945.
Duisburg, Wilhelm-Lehmbruck-Museum
◄ Clovis Trouille *The Temptations of Saint Anthony*, 1947. Private collection

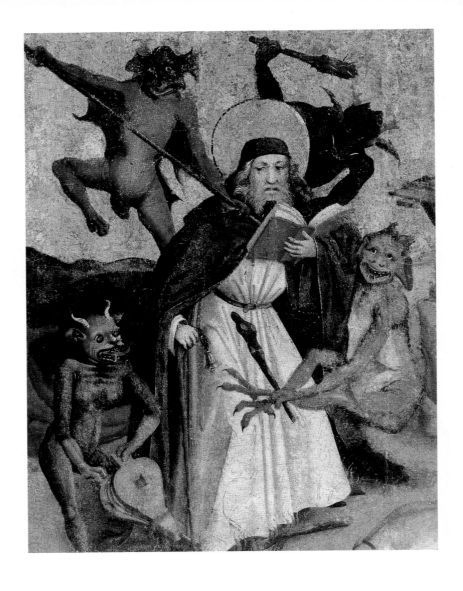

▲ **Master of 1445** *The Temptations of Saint Anthony,* mid 15th c. Constance, Rosgarten Museum
▶ **Salvator Rosa** *The Temptations of Saint Anthony,* c. 1660.
San Remo, Pinacoteca Rambaldi di Coldirodi

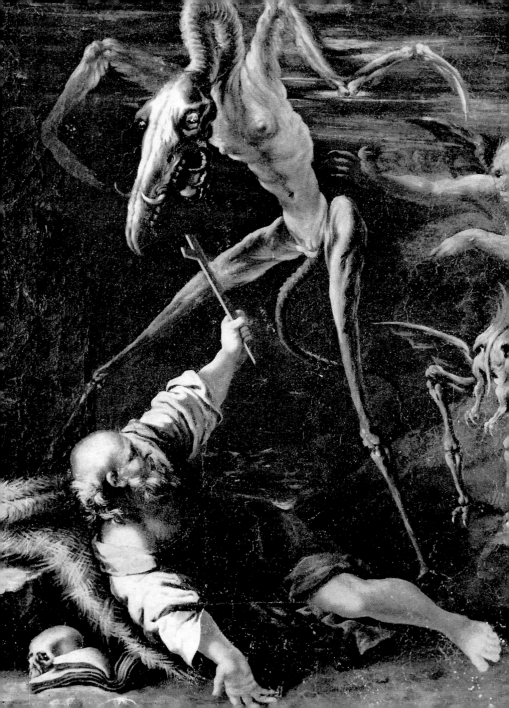

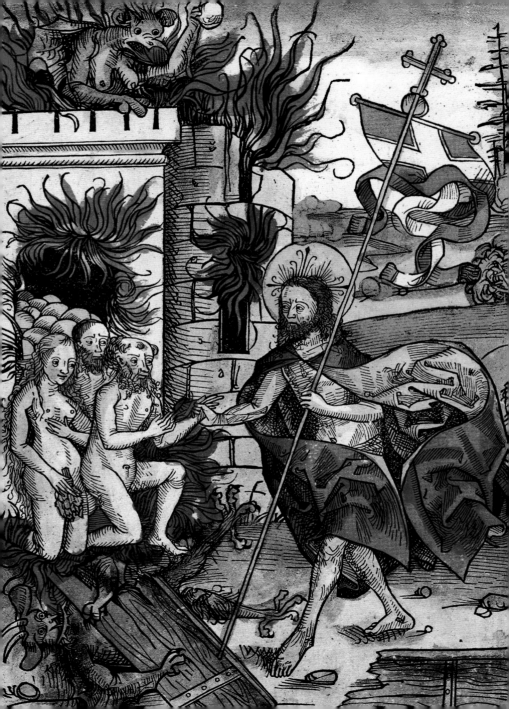

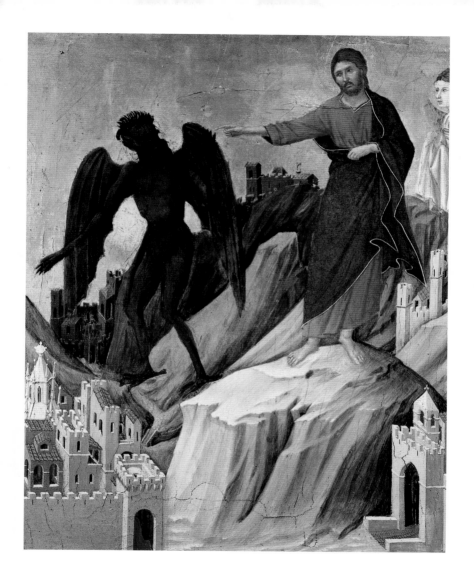

▲ **Duccio** *The Temptation of Christ on the Mountain* (detail), 1308–1311. New York, The Frick Collection
◄ **Michael Wohlgemuth** *Christ in Limbo.* Woodcut from a German prayerbook, Nuremberg 1491
►► *Angels Flying to Save a Soul from a Demon.* Miniature from an illuminated French manuscript
of the *Vie et Miracles de Notre-Dame*, 15th c. Paris, Bibliothèque Nationale 175

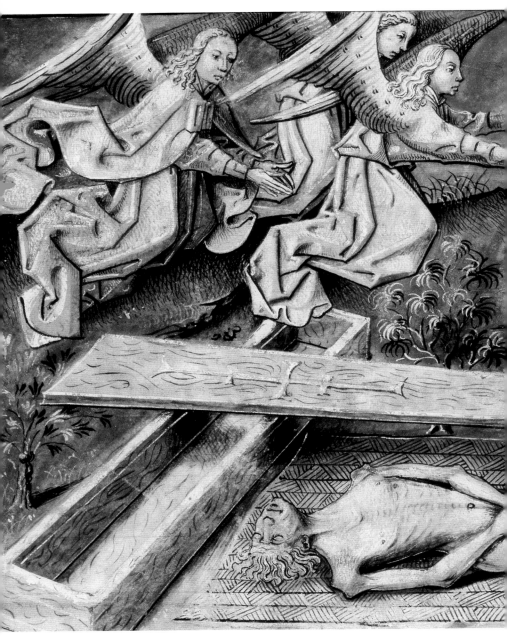

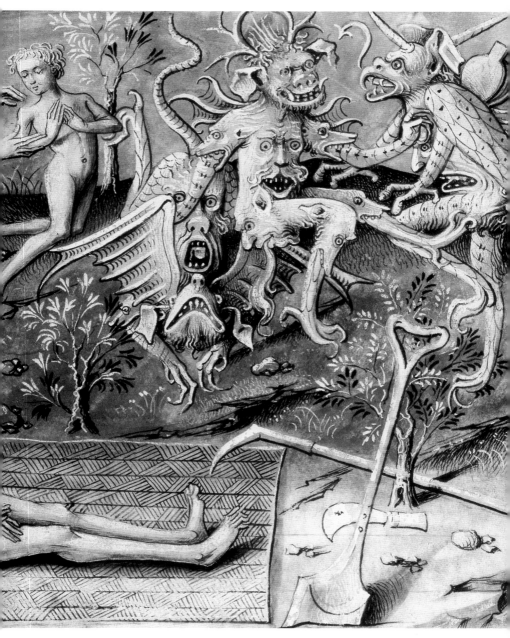

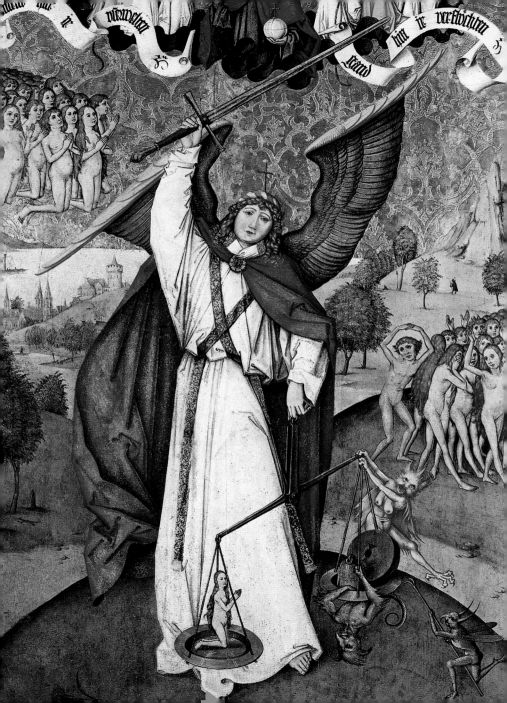

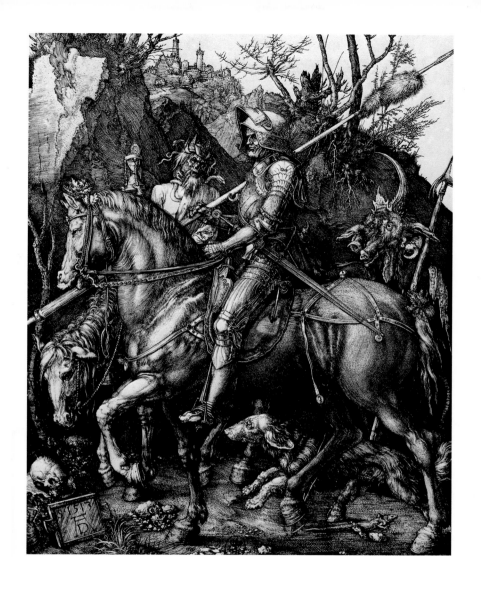

▲ **Albrecht Dürer** *The Knight, Death and the Devil*. Copper-plate engraving, 1513.
Paris, Bibliothèque Nationale
◄ **Master of the Carnation** *Altarpiece of Saint Michael* (detail), c. 1500. Zurich, Kunsthaus

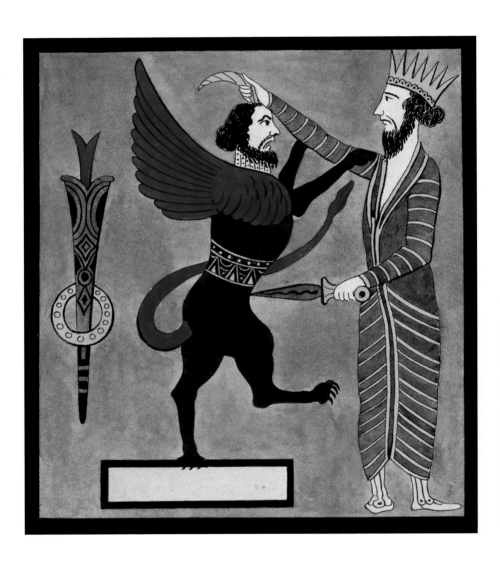

The Final Triumph of Good over Devil. Copy after an ancient frieze from Persepolis, 19th c.
Paris, Bibliothèque des Arts décoratifs

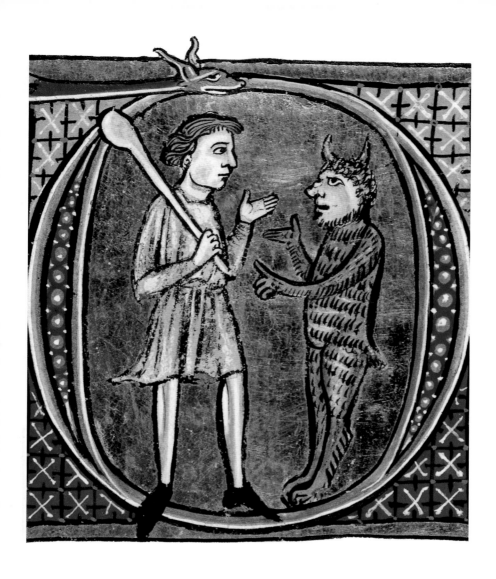

The Devil Arguing. Illuminated initial from a Latin Bible, 13th c.
Paris, Bibliothèque Mazarine

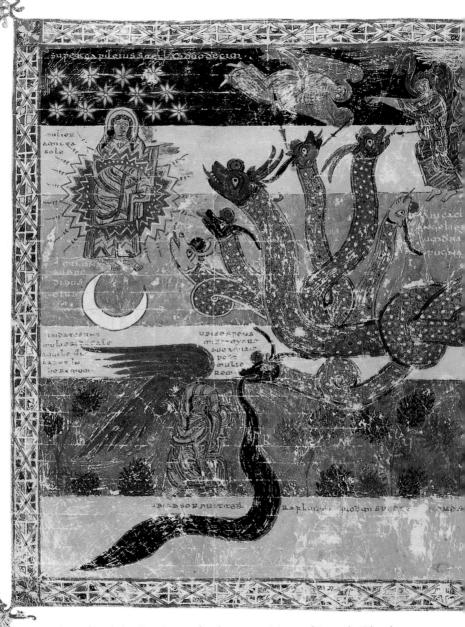

Apocalypse of Revelation. French copy of a 9th century miniature of Beatus de Liébana's
Commentaries on the Apocalypse, 13th c. New York, The Pierpont Morgan Library

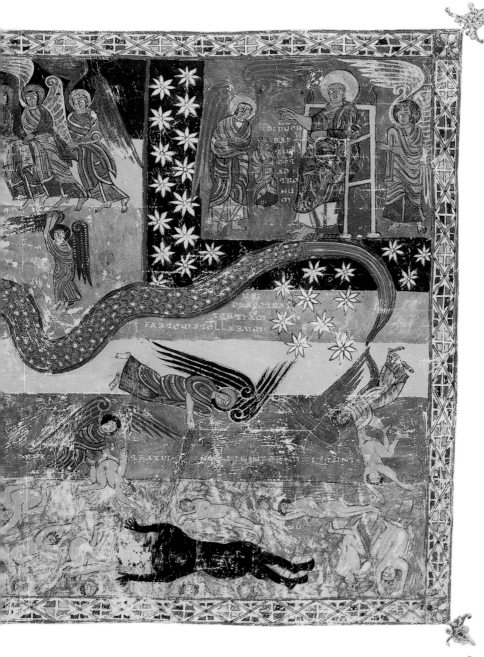

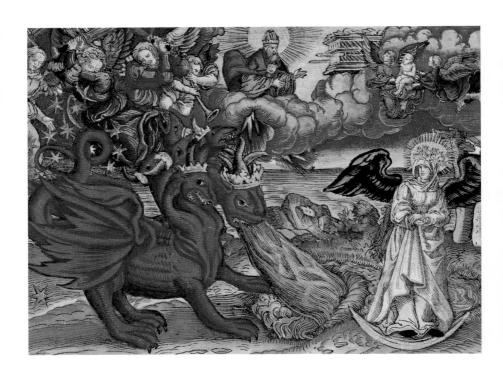

Saint Michael and his angels fighting the red dragon with the seven crowned heads.
Illustration from *The Luther Bible*, 1534

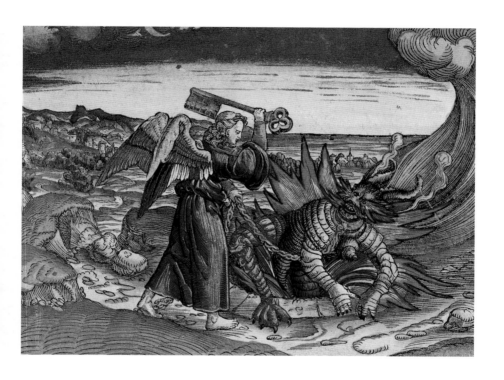

The angel with the key to the bottomless pit, binding the dragon for a thousand years.
Illustration from *The Luther Bible*, 1534

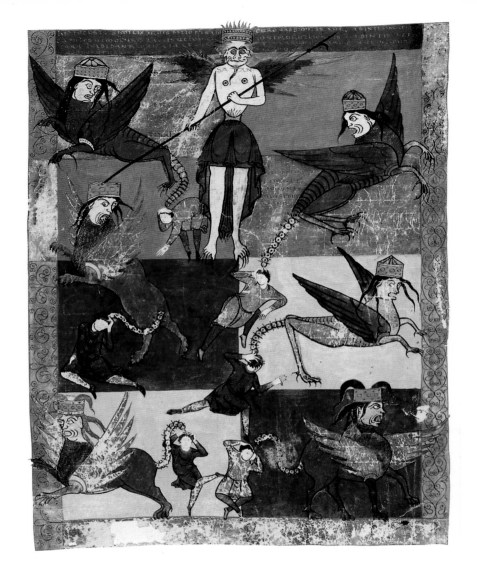

The Apocalypse. Spanish illuminated manuscript after the *Commentaries on the Apocalypse* by Beatus de Liébana (776–784), mid 10th c. New York, The Pierpont Morgan Library

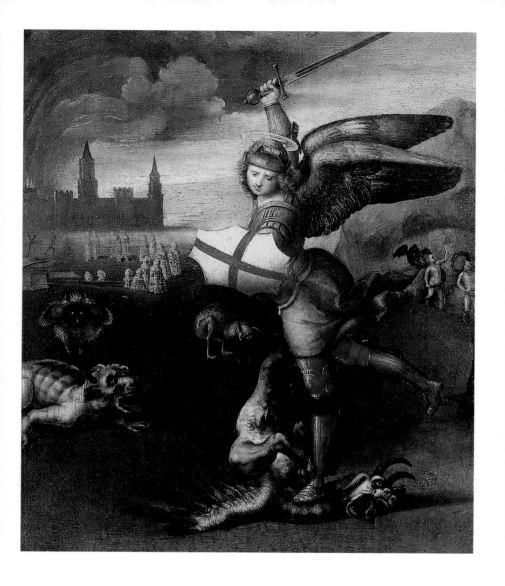

Raphael *Saint Michael Slaying the Dragon*, c. 1500. Paris, Musée du Louvre

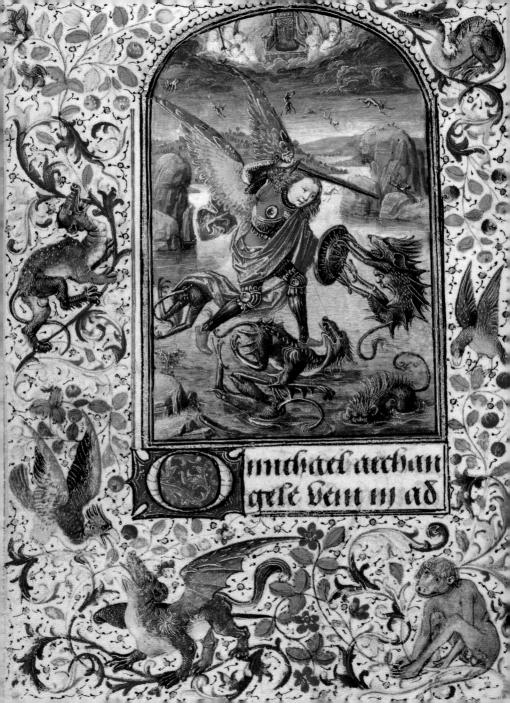

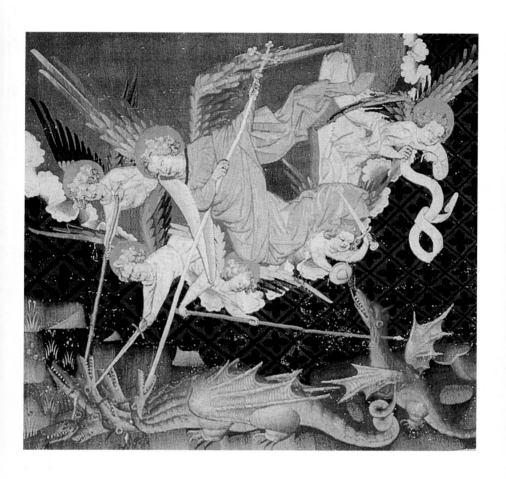

▲ *The Fight of the Angels against the Dragon* (detail of a tapestry), 14th c.
Angers, Musée de la Tapisserie de l'Apocalypse
◄ **Lieven Van Lathem** *Saint Michael.* Flemish miniature from the
Prayerbook for Charles the Bold, 1469. Los Angels, The J. Paul Getty Museum 189

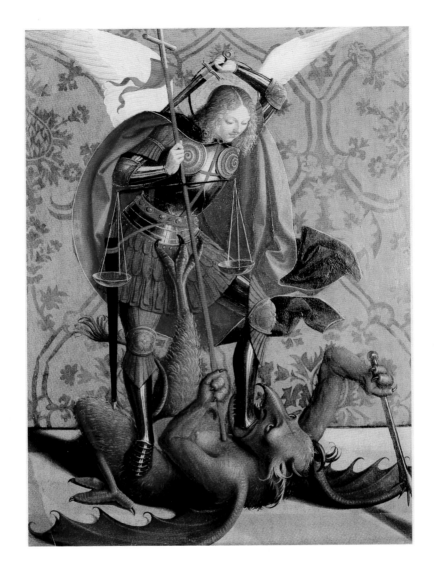

Josse Lieferinxe *Saint Michel Slaying the Dragon*, late 15th c.
Avignon, Musée du Petit-Palais

Acknowledgements & Credits:
The publishers wish to thank the copyright holders who greatly assisted in this
publication. Every effort was made to identify and contact individual copyright holders;
omissions are unintentional. In addition to those persons and institutions cited in the
captions, the following should also be mentioned: © Artothek, Weilheim: 144/145, 148/149,
157; © The Bridgeman Art Library, London/Archives Charmet: 20/21, 23, 26, 28, 39, 42, 57,
112, 114/115, 128, 167, 174, 180; © The British Museum, London: 91 © Instituto Português de
Museus, Lisbon (photo: Luis Pavão): 133; © Musée de la Publicité, Paris: 47, 48, 49, 50, 51,
52, 53, 54; © Musées royaux des Beaux-Arts de Belgiques (photo: Speltdoorn), Brussels: 18;
© The National Gallery, London: 98; © Photo Vatican Museums, Rome: 12, 15, 153, 154, 155;
© RMN, Paris: 63; © Scala, Florence: 173

© 2003 TASCHEN GmbH
Hohenzollernring 53, D–50672 Köln
www.taschen.com

© Succession Picasso/VG Bild-Kunst,
Bonn 2003 for Picasso
© VG Bild-Kunst, Bonn 2003
for the illustrations by Philippe Druillet, Max Ernst,
Alfred Kubin, Félix Labisse and Clovis Trouille
Text and layout: Gilles Néret, Paris
Editorial coordination: Kathrin Murr, Cologne
Production: Thomas Grell, Cologne
English translation: Chris Miller, Oxford
German translation: Bettina Blumenberg, Munich

Printed in Italy
ISBN 3–8228–2461–5

The Luther Bible of 1534
Stephan Füssel / Hardcover,
2 volumes + booklet, 1.888 pp.
€ 99.99 / $ 99.99 / £ 69.99 /
¥ 15.000

Angels
Gilles Néret / Flexi-cover, Icons,
192 pp. / € 6.99 / $ 9.99 /
£ 4.99 / ¥ 1.250

"These books are beautiful objects, well-designed and lucid." —*Le Monde*, Paris, on the ICONS series

"Buy them all and add some pleasure to your life."

All-American Ads 40ˢ
Ed. Jim Heimann

All-American Ads 50ˢ
Ed. Jim Heimann

Angels
Gilles Néret

Architecture Now!
Ed. Philip Jodidio

Art Now
Eds. Burkhard Riemschneider,
Uta Grosenick

Atget's Paris
Ed. Hans Christian Adam

Best of Bizarre
Ed. Eric Kroll

Bizarro Postcards
Ed. Jim Heimann

Karl Blossfeldt
Ed. Hans Christian Adam

California, Here I Come
Ed. Jim Heimann

50ˢ Cars
Ed. Jim Heimann

Chairs
Charlotte & Peter Fiell

Classic Rock Covers
Michael Ochs

Description of Egypt
Ed. Gilles Néret

Design of the 20ᵗʰ Century
Charlotte & Peter Fiell

Design for the 21ˢᵗ Century
Charlotte & Peter Fiell

Dessous
Lingerie as Erotic Weapon
Gilles Néret

Devils
Gilles Néret

Digital Beauties
Ed. Julius Wiedemann

Robert Doisneau
Ed. Jean-Claude Gautrand

Eccentric Style
Ed. Angelika Taschen

Encyclopaedia Anatomica
Museo La Specola, Florence

Erotica 17ᵗʰ–18ᵗʰ Century
From Rembrandt to Fragonard
Gilles Néret

Erotica 19ᵗʰ Century
From Courbet to Gauguin
Gilles Néret

Erotica 20ᵗʰ Century, Vol. I
From Rodin to Picasso
Gilles Néret

Erotica 20ᵗʰ Century, Vol. II
From Dalí to Crumb
Gilles Néret

Future Perfect
Ed. Jim Heimann

The Garden at Eichstätt
Basilius Besler

HR Giger
HR Giger

Indian Style
Ed. Angelika Taschen

Kitchen Kitsch
Ed. Jim Heimann

Krazy Kids' Food
Eds. Steve Roden,
Dan Goodsell

London Style
Ed. Angelika Taschen

Male Nudes
David Leddick

Man Ray
Ed. Manfred Heiting

Mexicana
Ed. Jim Heimann

Native Americans
Edward S. Curtis
Ed. Hans Christian Adam

New York Style
Ed. Angelika Taschen

Extra/Ordinary Objects, Vol. I
Ed. Colors Magazine

15ᵗʰ Century Paintings
Rose-Marie and Rainer Hagen

16ᵗʰ Century Paintings
Rose-Marie and Rainer Hagen

Paris-Hollywood
Serge Jacques
Ed. Gilles Néret

Penguin
Frans Lanting

Photo Icons, Vol. I
Hans-Michael Koetzle

Photo Icons, Vol. II
Hans-Michael Koetzle

20ᵗʰ Century Photography
Museum Ludwig Cologne

Pin-Ups
Ed. Burkhard Riemschneider

Giovanni Battista Piranesi
Luigi Ficacci

Provence Style
Ed. Angelika Taschen

Pussy Cats
Gilles Néret

Redouté's Roses
Pierre-Joseph Redouté

Robots and Spaceships
Ed. Teruhisa Kitahara

Seaside Style
Ed. Angelika Taschen

Seba: Natural Curiosities
I. Müsch, R. Willmann, J. Rust

See the World
Ed. Jim Heimann

Eric Stanton
Reunion in Ropes & Other
Stories
Ed. Burkhard Riemschneider

Eric Stanton
She Dominates All & Other
Stories
Ed. Burkhard Riemschneider

Tattoos
Ed. Henk Schiffmacher

Tuscany Style
Ed. Angelika Taschen

Edward Weston
Ed. Manfred Heiting